DATE DUE

Art in Context

Edvard Munch: The Scream

Art in Context

Edited by John Fleming and Hugh Honour

Each volume in this series discusses a famous painting or sculpture as both image and idea in its context – whether stylistic, technical, literary, psychological, religious, social or political. In what circumstances was it conceived and created? What did the artist hope to achieve? What means did he employ, subconscious or conscious? Did he succeed? Or how far did he succeed? His preparatory drawings and sketches often allow us some insight into the creative process and other artists' renderings of the same or similar themes help us to understand his problems and ambitions. Technique and his handling of the medium are fascinating to watch close up. And the work's impact on contemporaries and its later influence on other artists can illuminate its meaning for us today.

By focusing on these outstanding paintings and sculptures our understanding of the artist and the world in which he lived is sharpened. But since all great works of art are unique and every one presents individual problems of understanding and appreciation, the authors of these volumes emphasize whichever aspects seem most relevant. And many great masterpieces, too often and too easily accepted and dismissed because they have become familiar, are shown to contain further and deeper layers of meaning for us.

Art in Context

Edvard Munch *was born in Løten, Norway, on 12 December 1863, the eldest son of a military doctor in a family whose ancestors included some of Norway's most renowned historians, poets, bishops and painters. In 1864, the family moved to Kristiania (as Oslo was then called). He began to study painting in 1881, and soon allied himself with the Norwegian Naturalist painters led by Christian Krohg. In 1889, he went to Paris and found among the avant-garde painters the means to further his own anti-naturalistic intentions. The themes of love and death became his primary concern, and in 1893 he united several of his paintings, including* The Scream, *into a series through which he could symbolize the universality of his personal emotions. Throughout the 1890s, he worked on this series of paintings and graphics; in 1902, in Berlin, the final* Frieze of Life *was exhibited. After a nervous breakdown in 1908, he settled again in Norway, thus ending the turmoil of his bohemian existence in Germany and France, but also losing the unity of purpose which had marked his art since the 1880s. But he gained in honor as he became recognized as a major precursor of Expressionism and as Norway's greatest painter. He died in his house in Ekely, near Oslo, on 23 January 1944.*

The Scream *was painted in mixed media of oil, pastel and casein on cardboard (91 x 73·5 cm.). Several preparatory sketches as well as a painting preceded the final work, which was completed in the fall of 1893. The original painting is in Oslo's National Gallery; several later versions exist in private collections and in the Munch Museum, Oslo. Munch also made a lithograph of* The Scream *in 1895.*

New York The Viking Press

Edvard Munch: The Scream

Reinhold Heller

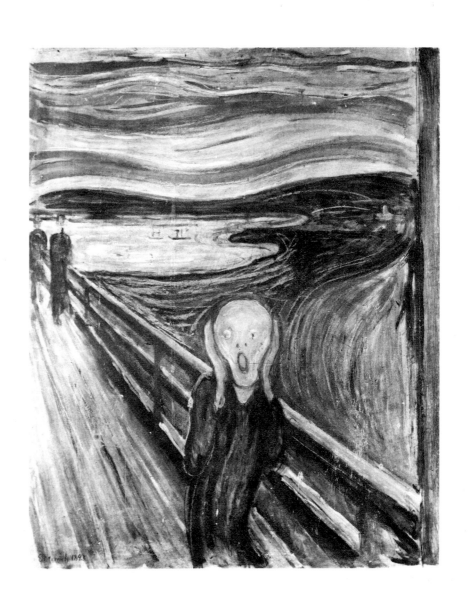

Copyright 1972 in all countries of the International Copyright Union by Reinhold Heller
All rights reserved
Published in 1973 by The Viking Press, Inc.
625 Madison Avenue, New York, N.Y. 10022
SBN 670-28955-8
Library of Congress catalog card number: 70-180829
Filmset in Monophoto Ehrhardt by Oliver Burridge Filmsetting Ltd, Crawley, England
Color plate printed photogravure by D. H. Greaves Ltd, Scarborough, England
Printed and bound by W. & J. Mackay & Co. Ltd, Chatham, England

Designed by Gerald Cinamon and Veronica Loveless

To my son Frederik

Reference color plate at end of book

Acknowledgments

The initial research from which this study developed was made possible through a grant from the Foreign Area Fellowship Program of the American Council of Learned Societies and the American Social Science Research Council; to this program, and to Miss Dorothy Soderlund and Mr James Gould who administered the grant, I wish to extend my thanks and appreciation. I also owe great debts of training and informative criticism to Professors Albert Elsen, John Jacobus and Sven Loevgren. The entire staff of the Munch Museum and the National Gallery in Oslo have, likewise, been of immeasurable aid to me in making me familiar with the art of Munch as well as of other Norwegian artists who are far too easily neglected by scholars outside Scandinavia. For their friendship which made research so much more pleasant and for their numerous lengthy conversations and discussions with me, I am particularly grateful to Mr Pål Hougen, Director of the Munch Museum, and to Mr Trygve Nergaard of the University in Oslo; without their extremely generous aid, my knowledge of Munch and his work would have remained greatly limited. My colleagues and students at the University of Pittsburgh have also been most helpful in their willingness to listen and offer suggestions. The task of typing was shared by Mrs Joan Rabenau, Mrs Patricia Pepin and by my wife, without whose enthusiastic affirmation of my studies, seconded by my mother, this book would not exist.

Historical Table

1888	Wilhelm II becomes German Emperor.
1889	Hitler born. Crown Prince Rudolf commits suicide at Mayerling. First International Socialist Congress in Paris.
1890	Bismarck dismissed.
1891	Pan German League founded. Triple Alliance renewed. Papal encyclical *Rerum Novarum* by Leo XIII. Color photography developed.
1892	
1893	German Army Bill passed. Anarchist bomb thrown in French Parliament.
1894	Panama Scandal. Dreyfus Trial. President Carnot of France assassinated. Nicholas II becomes Tsar of Russia.
1895	X-Ray, cinematograph and wireless telegraph invented.
1896	Battle of Adowa.
1897	Queen Victoria Diamond Jubilee.
1898	Death of Bismarck and Gladstone. Fashoda incident. Empress Elizabeth of Austria-Hungary assassinated. Spanish-American War.
1899	Boer War begins. The Hague Peace Conference.
1900	Boxer Rebellion. King Umberto of Italy assassinated.

Munch, *Evening (Loneliness)*. Gauguin, *Jacob Wrestling with the Angel*. Van Gogh, *Night Café*. Ensor, *Entry of Christ into Brussels*.

Munch has his first one-man exhibition in Kristiania; goes to France; his father dies on 28 November. Synthétiste Exhibition, Paris.

Munch ill at St Cloud; spends summer in Norway. Van Gogh dies. Cézanne, *Card Players*. Hodler, *Night*.

Munch in Nice; summer in Norway; exhibits in Munich. Van Gogh retrospective exhibition in Paris. Seurat dies. Gauguin in Tahiti.

Munch in Nice; summer in Norway; exhibits in Berlin; meets Strindberg, Przybyszewski and Ola Hansson. Paints *The Kiss* and *Despair*. Munich Secession founded. Horta, Hôtel Tassel, Brussels.

Munch exhibits in Berlin, Copenhagen, Breslau, Dresden and Munich; summer in Norway; paints **The Scream**. Monet, *Rouen Cathedral*. Rodin begins *Balzac*. *The Studio* begins publication.

Munch in Berlin; *Das Werk des Edvard Munch* published. Gauguin, *The Day of the God*.

Munch in Germany, France and Norway; his brother dies. Galerie de l'Art Nouveau founded in Paris. *Pan* begins publication.

Munch exhibits at Bing's Galerie de l'Art Nouveau; interior by Van de Velde. Kandinsky and Jawlensky arrive in Munich. *Die Jugend* begins publication.

Munch in Paris and Kristiania. Vienna Secession founded. Picasso enters Madrid Academy. Matisse, *The Dessert*. Gauguin, *Where Do We Come From? Who Are We? Where are We Going?* Horta begins Maison du Peuple, Brussels.

Munch travels in Norway, Denmark, Germany and France. Cézanne begins *Large Bathers*. Mackintosh, Glasgow School of Art. Guimard begins Paris Subway Stations. Minne, *Fountain of Youth*. *Ver Sacrum* begins publication.

Munch travels in France, Germany and Italy; in autumn enters Kornhaug Sanatorium in Norway; begins *The Dance of Life*.

Munch convalescing in Norway and Switzerland. Denis, *Hommage to Cézanne*. Van de Velde, Folkwang Museum, Hagen begun.

Nietzsche, *Der Fall Wagner*. Strindberg, *Miss Julie*. Ibsen, *The Lady from the Sea*. Theodor Storm, *Der Schimmelreiter*. Mahler, Symphony No. 1. — 1888

Nietzsche, *Twilight of the Idols*. W. James, *Principles of Psychology*. Tchaikovsky, *Sleeping Beauty*. — 1889

Hamsun, *Hunger*. Ibsen, *Hedda Gabler*. Lie, *Onde Magter (Evil Powers)*. Wilde, *Picture of Dorian Gray*. Huxley, *Agnosticism*. George, *Hymnen*. Wedekind, *Frühlings Erwachen*. — 1890

Revue Blanche founded. Lagerlöf, *Gösta Berlings Saga*. Vilhelm Krag, *Poems*. Huysmans, *Là-Bas*. Hermann Bahr, *Die Ueberwindung des Naturalismus*. — 1891

Nietzsche, *Also Sprach Zarathustra*. Hauptmann, *The Weavers*. Przybyszewski, *Towards a Psychology of the Individual*. Maeterlinck, *Pelléas and Mélisande*. Ibsen, *The Master Builder*. Jonas Lie, *Trold*. — 1892

Przybyszewski, *Totenmesse*. Dauthendey, *Ultra-Violett*. Sudermann, *Heimat*. Wilde, *Salome*. Heiberg, *The Balcony*. Obstfelder, *Poems*. Hans Jæger, *Syk Kjærlihet*. Sibelius, *Karelia Suite*. — 1893

Hamsun, *Pan*. Hauptmann, *Hannele's Himmelfahrt*. D'Annunzio, *Triumph of Death*. Grieg, *Wedding Day at Troldhaugen*. Mahler, Symphony No. 2 *(The Resurrection)*. — 1894

Nietzsche, *The Anti-Christ* and *Nietzsche Contra Wagner*. Przybyzewski, *Vigilien*. Fontane, *Effie Briest*. Wedekind, *Der Erdgeist*. Strindberg, *The Confession of a Fool*. Freud, *Studien über Hysterie*. — 1895

Ibsen, *John Gabriel Borkman*. Chekhov, *The Seagull*. Obstfelder, *The Cross*. Jarry, *Ubu-Roi*. Sienkiewicz, *Quo Vadis*. Bergson, *Matière et Mémoire*. — 1896

Przybyszewski, *Over Board*. Strindberg, *Inferno*. Chekhov, *Uncle Vanya*. Hauptmann, *Die Versunkene Glocke*. Obstfelder, *Drops of Red*. Havelock Ellis, *Studies in the Psychology of Sex* (Vol. I). — 1897

Henry James, *The Turn of the Screw*. Rilke, *Advent*. Strindberg, *The Road to Damascus* (Parts I and II). Bjørnson, *Paul Lange*. Tolstoy, *What is Art?* — 1898

Ibsen, *When We Dead Awaken*. Wundt, *Comparative Psychology*. Sibelius, Symphony No. I and *Finlandia*. Schoenberg, *Verklärte Nacht* (String sextet). — 1899

Freud, *Die Traumdeutung*. D'Annunzio, *Il Fuoco*. Obstfelder, *A Priest's Diary*. Strindberg, *The Dance of Death*. Bergson, *Le Rire*. Mahler, Symphony No. 4. — 1900

1. The Frieze of Life

In his review of the Berlin Secession Exhibition in 1902, the influential critic Karl Scheffler recalled the dichotomy set up between painting and poetry in Lessing's eighteenth-century aesthetic treatise *Laokoön*. The Secession artists, Scheffler discovered, were turning away from Impressionism toward an art of dramatic content, thus laying themselves open to those 'literary' dangers and temptations described by Lessing. Scheffler's review announced a program containing the basic goals of Expressionism three years before the founding of the Brücke in Dresden, the first organized group of German Expressionist painters. The German artist, he noted, lacking the light and lively temperament of the French, should rely on his own racial intuitions to create an art of world stature: 'For him there can be progress only if he masters great poetic themes by using the new discoveries of our revolutionized modern emotional life while building on the results of impressionism.' As a 'typical product of our ruling spiritual fever', he recognized one of Expressionism's essential forerunners in the Norwegian painter Edvard Munch. 'There never existed a painter with a greater desire for a lyrical emotional life; but his unhappy intellect never lets him forget the worm concealed in every bud, the grimacing skull beneath every face, the beast lurking behind every passion, Nature's arbitrary whims in every painful sensation: and with dazed amazement, beckoned on by mocking insanity with outstretched arms, he walks through the inferno of this life as someone atavistically burdened with talent.'[1]

What impressed Scheffler was a cycle of twenty-two paintings hung as a frieze in the sculpture hall of the Secession [1, 2, 3].

1. Leipzig exhibition, 1903, of Munch's *Frieze of Life*

Described in the catalogue as a series of 'pictures of life', the frieze
was divided into four sections: Seeds of Love, Flowering and Passing
of Love, Life Anxiety, and Death. Munch exhibited these *Motifs
from the Life of a Modern Soul*, generally known as the *Frieze of Life*,
again in Leipzig in 1903, in Kristiania (Oslo) in 1904 and in Prague
in 1905; thereafter, although he considered it his most important
work, he never showed it again and in 1909 disbanded it. But later

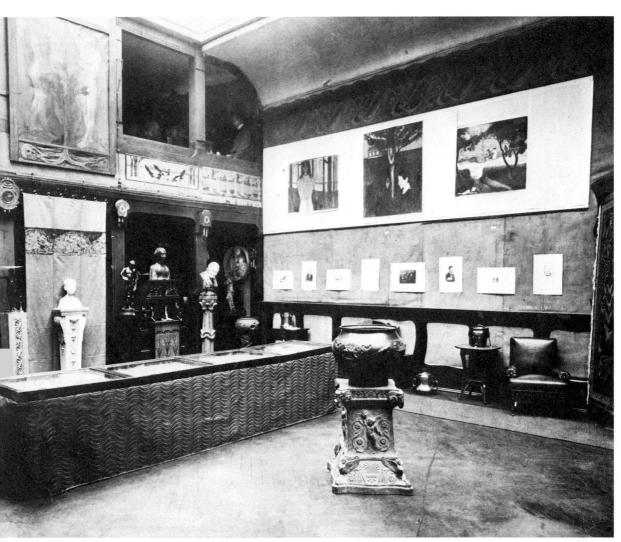

in his life he painted new versions of many Frieze paintings and always hoped to find a proper architectural setting for them. On his death in 1944, at the age of eighty, he left his works to the city of Oslo, with the condition that they would remain united and that his Frieze paintings would once more be seen together as intended.

The work on this series of paintings runs like a long, twisted and slowly unravelling thread throughout Munch's life, finding reflection in almost everything he created, acting as a continuous burden

2, 3. Leipzig exhibition, 1903, of Munch's *Frieze of Life*

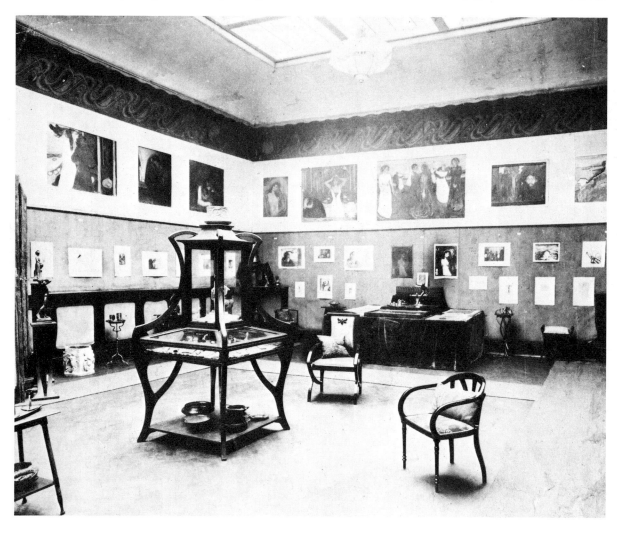

on new ideas or changing conceptions in his art, refusing to free its creator. The content of the Frieze, the great themes of love and death, intruded early into both Munch's life and art. Death was the initial experience. It came in 1868, when the artist's mother died of tuberculosis shortly after giving birth to his youngest sister, Inger. The memory of the last Christmas which he spent with his mother remained a haunting theme later recorded in 1892 in one of his remarkable prose poems.[2]

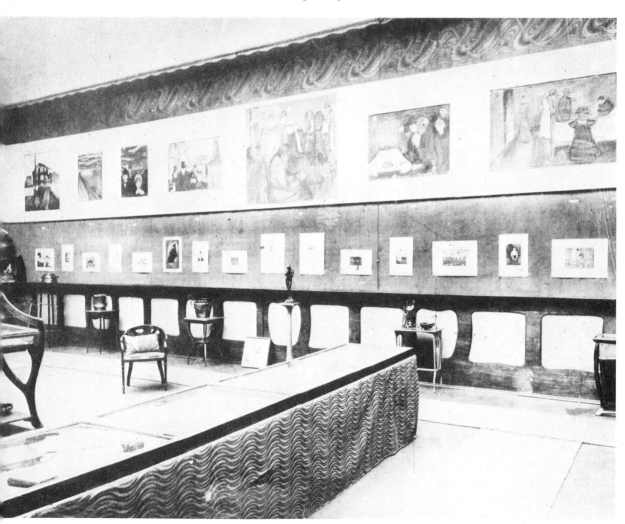

Huge snowflakes fell, endlessly, endlessly. We saw them dropping from the air, legions of snowflakes, and we could follow them with our eyes until they were almost on the ground. There they all lay down so softly, one on top of the other one. The snow lay there like a carpet. They were so white and soft. And on the roofs and outside the windows, all the way up to the windowpane, they lay down, so wet and white.

There were so many white candles all the way to the top of the tree. Some were dripping. The light shone in all colors, but mostly in red and yellow and green. I almost could not see for all the light.

The air was heavy with the smell of wax and burnt greens. There were no shadows anywhere; the light crept into all corners and crevices.

She sat in the middle of the sofa in her heavy black dress which seemed even blacker in that sea of light, silent and black.

All around her we five either stood or sat. Father walked back and forth on the rug, and then sat down next to her on the sofa, and they whispered something and bent their heads towards each other. She smiled and tears ran down her chin. It was so silent and light everywhere.

And then Berta [i.e. Sophie] sang, 'Silent night, holy night, angels float to earth unseen.'

And something suddenly opened and we could see far, far into heaven, and saw angels float quietly, smiling and wearing long white robes. And we were all so deeply moved, so deeply moved.

The woman on the sofa looked at us, from the one to the other, and stroked our cheeks with her hands.

*

We had to leave.

A strange man, dressed all in black, stood at the foot of the bed and prayed.

It was dark in the room now and the air was heavy and grey.

We had on our coats and the girl who was going with us stood in the doorway and waited.

And so we had to go up to the bed one by one, and she looked at us so strangely and kissed us. And then we left, and the girl took us to some strangers. They were all so good to us and gave us as many cookies and sweets as we wanted.

They woke us in the middle of the night.

We understood at once.

We got dressed with sleep in our eyes.

The memory of death reappeared when Munch himself suffered from tuberculosis, and fever brought him visions of the devil, and again when Sophie, his favorite sister, died in 1877. Again snow fell and lights reflected from roofs and windows, this time in Paris, when Munch received the news that his father had died in 1889, that he had sent his Bible to Paris to save his son's threatened soul.

4. *The Artist's Father.*
E. Munch, *c.* 1881

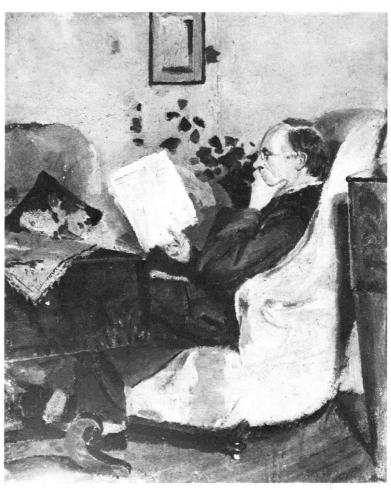

Love mingled with death. Those he loved most were dead, and he continued his identification with them in death:

When I light the lamp, suddenly I see my own enormous shadow ranging over half the wall and up to the ceiling. And in the big mirror above the fireplace I see myself, the face of my own ghost.

And I live with the dead – my mother, my sister, my grandfather and my father, mostly with him. All memories, even the smallest things, return.

The remembrance of his deeply religious father, the devoted doctor of Kristiania's slums [4], brought with it a sense of guilt felt for other loves. His father had prayed late at night to save his son from the sinful attractions of women, flesh, and free love, but the diabolic allures of alcohol and a bohemian life overpowered his prayers, raising a barrier of incommunicative tensions between father and son:

He could not understand my desires. I could not comprehend what he valued above them. God settled our accounts.

Did you know what I suffered, Father? Did you realize why I was so harsh? I was not just my self alone. She was in me. She was in my blood.

She was married and he was twenty when she aroused Munch's erotic dreams:

We sat across from each other. Our eyes met. A reddish shadow over everything.

And then she sat up taller and leaned her head back against the sofa. And so I had to look more closely at a strange pattern in the upholstery and I bent over towards her so that our cheeks touched. And I felt how close we were to each other.

Munch recorded his encounters with numerous other women in the manuscript he entitled *From the City of Free Love*, his memories of the 1880s. By 1885, he was working on several paintings and drawings with erotic motifs; at the same time he began his first depiction of approaching death, the memory of his dying sister represented in the painting *The Sick Child* [5].

In Munch's thoughts, and in much of his work, this perpetual concurrence of love and death became almost an obsession. On

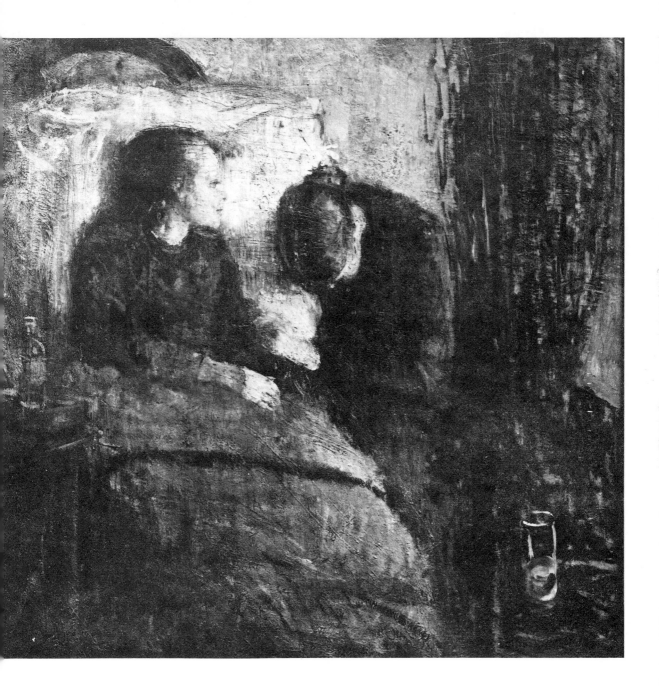

5. *The Sick Child.* E. Munch, 1885-6

New Year's Eve, 1889, love and death were the themes he considered in his 'St Cloud Manifesto', the program for his art which was born of the melancholy broodings over his father's death:

A strong naked arm, a tanned powerful neck – a young woman rests her head on the arching chest. She closes her eyes and listens with open, quivering lips to the words he whispers into her long flowing hair.

I would give form to this as I now see it, but envelop it in a blue haze. These two in that moment when they are no longer themselves but only one of thousands of links tying one generation to another generation. People should understand the sanctity of this and take off their hats as if they were in church.

I would make a number of such paintings.

No longer would interiors, people who only read and knit, be painted. There should rather be living people breathing and feeling, suffering and loving. I feel I have to do this. It would be so simple. The flesh would take on form and the colors come to life.[3]

What Munch announced in this program was not only a sexually oriented content for his work, but also an analysis of love itself as it caused man and woman to lose their identity in each other in order to perpetuate the species, to gain immortality in the person of a child and thus form themselves into a link in the chain of human generations. That love, notably the physical act of love, not only brought life but also death, he clarified in a commentary on his *Madonna: The Loving Woman* [22, 23]:

It is the moment when all the world stands still . . . Your face contains all earth's beauty. Your lips, crimson red like your ripening fruit, glide from each other as if in pain . . . A corpse's smile . . . New life shakes the hand of death. The chain binding the thousand dead generations to the thousand generations to come is linked together.

The problem which Munch posed himself was how to place this content into his paintings, how to present these thoughts of immortality to an age whose faith in science and evolution had replaced the faith in its Christian heritage. Darwin's theories introduced Munch to a new concept of immortality, totally re-

versing the immortality of which St Paul wrote (I Corinthians xv, 22): 'For as in Adam all die, even so in Christ shall all be made alive.' The new immortality was founded specifically in Adam, and emphasized the continuation of human terrestrial life rather than an everlasting extra-terrestrial salvation or condemnation. The Christian iconographic themes which had nourished Western European art for over 1,500 years had become as historical as had the faith, incapable of satisfying Munch's desire for contemporary content and expression. As the modern spiritual content, Munch then proclaimed that he would paint '*det menneskelige*' – that which is specifically human – 'With its sufferings and emotions, rather than paint external nature.'[4] Putting his new, anti-naturalist aesthetic into words in 1891, he wrote:

This way! This is the path to painting's tomorrow, to art's promised land! In these paintings the painter depicts his deepest emotions, his soul, his sorrows and joys. They display his heart's blood . . .

He depicts the human being, not the object . . .

These paintings are designed to move people intensely, first a few, then more and more, and finally everyone . . .

And it is, after all, precisely this, and this alone, that gives art a deeper meaning. It is necessary to depict man, life, and not lifeless nature . . .

It is true that a chair can be just as interesting as a man, but the chair must be seen by a man. In one way or another, he must have had an emotional reaction to it and the painter must cause the viewer to react in the same way. He must not paint the chair, but rather that which a human being has felt about it.

That subjective experience, the personal emotions of the artist, should determine the content and form of the painting was hardly a goal unknown in earlier art. Xenophon tells us that Socrates already sought to persuade artists to depict the states of the soul rather than just external forms. Even more emphatic, however, were the writers and artists of German Romanticism. In 1798, Ludwig Tieck, in his novel *Franz Sternbald's Travels*, had the painter-hero write: 'You cannot believe how much I wish to paint something which expresses totally the state of my soul and which

would arouse the same emotions in others . . . Every viewer would have to wish himself into the painting and forget his actions and plans, his education and political ideologies for a short time, and perhaps he would then feel the same way as I do now as I write and think about this.'[5] The same thoughts appear among aphorisms written by the painter Caspar David Friedrich: 'The painter should depict not only what he sees before him, but also what he sees inside himself . . . Close your physical eyes so that you see your picture first with your spiritual eye. Then bring forth what you saw inside you so that it works on others from the exterior to their spirit.'[6] This Romantic viewpoint, that the subjective spiritual state of the painter seeks an expression through which to communicate itself to others, likewise became associated with attempts to found a new religious art. The Nazarenes, for example, rejected their Baroque and Neo-classical predecessors because they had failed to speak to the heart; Friedrich Overbeck expounded in 1810 an art of 'the heart, the soul, the emotions', a true art 'which follows its innermost essence in evolving from religion, acquires its spirit and life from this fount and then gives them its own proper artistic form'.[7]

But while the Nazarenes attempted to resurrect Christian art, Philipp Otto Runge reacted more radically to the situation:

We stand at the end of all those religions which evolved from Catholicism. Abstractions are dying; everything is airier and lighter than heretofore; we are moving into the direction of the landscape, are seeking something definite in this infinity and do not know where to begin . . . Is there not also in this new art – landscape-making, if you want – a high point to be achieved? which perhaps will be even more beautiful than what preceded? I wish to represent my life in a series of paintings; when the sun sinks and when the moon gilds the clouds, I want to hold fast the fleeting spirits.[8]

Religion, according to Friedrich Schlegel, was no longer something objective, a historical sequence of events and a faith of defined dogmas, but rather it was an individual view of the infinite. The

German Romantics, notably Runge and Friedrich, found this infinity within themselves, in introspection, in their own emotions, and visually interpreted it through landscape, creating mood paintings demanding a sympathetic reaction in the viewer.

In French Impressionism nineteenth-century landscape painting attained its most mature expression, but the representation of the artist's inner life was lost to the objective image of light on the artist's retina. There is no direct line of evolution, no visual tradition, which ties Romanticism's subjectivity at the beginning of the century to the subjectivity of Munch at the end of the century. Isolated painters with isolated formal vocabularies may become links in the chain of ideas, but such painters as Böcklin or Hodler or Redon are stylistic anomalies. If Munch can claim direct descent from Romanticism, it is through a revival of Romanticism.

In Norway, as elsewhere in Europe, Romanticism had died out as a movement in the arts by the 1850s and was replaced by an aesthetic emphasizing contemporary life faithfully depicted in detail. Early in the 1880s Frits Thaulow and Christian Krohg became the spokesmen for *plein-airist* landscape painting and politically laden representations of urban or peasant life; Munch's earliest work enthusiastically attempted to equal the accomplishments of these exemplars. Although treating a realist motif, *The Sick Child* [5] marked Munch's break with their teachings; everything in the painting served only one purpose: to render the melancholy memory of his sister's death so intensely that the viewer will recognize and share the scene's hopeless mood. In this sudden turn from visually faithful contemporary scenes to emotionally faithful memories, to the use of nature and art for their associative rather than purely visual values, he was accompanied by numerous other Norwegian artists as German Romantic *Stimmungsmalerei* was translated into Norwegian *stemningsmaleri*.

Andreas Aubert, the Norwegian biographer of Caspar David Friedrich, pronounced that Norwegian artists should choose motifs 'in which we can feel that they were really something [the artist]

himself truly appreciated'.[9] While Aubert was demanding a 'spiritual rendering of reality', Christian Krohg named Munch the first of a new generation of Norwegian artists: 'The greatness of Munch's art, with which we have to come to terms, is that he paints solely what he feels. We are never in doubt as to why he paints something.'[10] As an example of the art of the future, Krohg pointed to the painting *Evening: Loneliness* [6], a work resulting from the impression of quiet and isolation Munch received while walking on a summer's night. The scene concentrates on a long, curving road moving through the center of a moonlit landscape

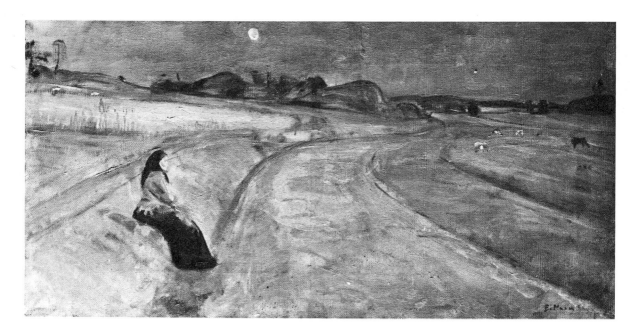

populated only by a few grazing cows and, in the foreground, the isolated figure of a seated woman. As in landscapes by Friedrich [7], a small figure appears viewing the vastness of nature surrounding it. The woman of Munch's painting serves as a representative for the artist, but also serves as an entrance to the picture for the viewer, a projection of his own subjective ego into the landscape and its mood of isolation. Rather than being a repre-

sentation of a specific moment in time, of a specific scene, the painting became a dream image for the pathos of loneliness. Painting served to make the invisible visible, in direct antithesis to realism's dictum that only what is seen can be painted.

The content and format of *Evening*, with its vaguely melancholy mood, was essentially a resurrection of Romantic formulae; the limitations of Naturalism were overcome by a reversion to pre-naturalist content. Munch had not yet entered on the 'path of art's tomorrow'. When Karl Scheffler in 1902 said that the new art would make use of 'the discoveries of our revolutionized

6 *(left)*. *Evening: Loneliness.*
E. Munch, 1888

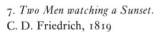

7. *Two Men watching a Sunset.*
C. D. Friedrich, 1819

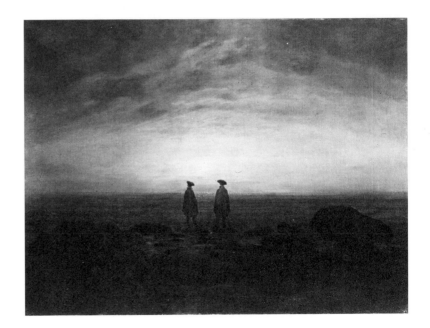

modern emotional life' and would build on 'the results of impressionism', he also portrayed Munch as 'a Romantic who can not lie'. The formulation is significant, a codification of Munch's mature art which took the romanticism of *Evening*, applied the revolutionary vocabulary of contemporary French art, and with the result reversed the sight- and object-oriented aesthetic of Naturalism by arriving at the conclusion: 'I paint, not what I see, but what I saw.'

Scheffler recalled Lessing's distinction between the content of literature and painting, that painting could not simply obtain an image from the descriptions of the poet but rather had to discover a dramatic moment concentrating into a single action the meaning to which a poet might devote lengthy scenes; not a single temporal moment should be selected, but rather a characteristic plastic expression which condenses into a unique action the moments of past and future. The problem of subject matter and art's proper vocabulary, raised by Lessing in 1766, was to plague the artist throughout the nineteenth century, culminating in the quasi-abstract definitions of painting by Conrad Fiedler and Maurice Denis. For Munch the problem arose once he rejected the topic-less depictions of landscapes; accepting the human soul, psychological life, as the drama he sought to present, and trained in Naturalism's insistence that the artist experience what he paints, he concentrated on an autobiographical narration on the nature of love and death. The goal had been set by 1889, in his 'St Cloud Manifesto', but the means – Lessing's single action abstracted from temporally limited moments, what Munch often described as 'crystallization' – were not formulated until March 1893, in a letter to the Danish painter Johan Rohde: 'I am working on a series of paintings at the moment . . . I believe [my paintings] will be more easily understood once I put them all together. The series will deal with love and death.' In other words he would combine several images into a cycle of works concentrating on a single theme. One work of art should explain the other. Each painting, although physically distinct and with a unique motif, would become a spiritual fragment serving to aid in the creation of a greater unit; combined, they were to bring a total statement on human love and death. The effect would be cumulative. Each painting could still be viewed separately, but its full meaning would not be revealed except within the coordination of commentary provided by the remainder of the series. Although he had not done so when he painted them, in 1893 Munch determined that many of his paintings

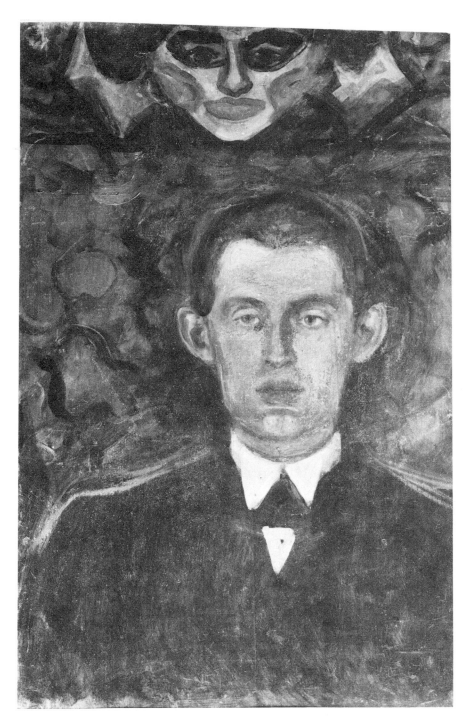

*8. Self-Portrait
under Woman's Mask.
E. Munch, 1892–3*

of 1891 and 1892 should be seen only in conjunction with each other, that their inter-related themes should be made manifest within the structure of a serial narrative. In this he assumed some of the power Lessing had relegated to the poet and had denied the painter. Literature's element of time, the revelation of a number of actions following upon each other, became an aspect of Munch's art as the content of each painting added to the content of the preceding one and pointed towards the following one; a plot was created whose totality was greater than the specific content of the paintings creating it.

The catalyst for this decision to create a series of paintings was the experience of seeing all his work displayed together in large one-man exhibitions. The first of these took place in Kristiania, where fifty paintings by Munch were exhibited from 14 September until 4 October 1892. Immediately following this, as guest of Berlin's Artists' Association, Munch exhibited fifty-five paintings which caused a major scandal forcing the show's early closing but this publicity also made it possible for Munch to arrange additional exhibitions throughout Germany in 1892–3.[11] By the time he wrote to Rohde in March 1893, Munch had arranged his paintings in six major exhibitions within the space of six months; each time he could see and review the entire course of his career as an artist, and could also display the works in a manner which most clearly revealed his intentions, which worked towards a total effect not possible in a single canvas. In a letter to the Norwegian art historian Jens Thiis, Munch later explained that when he placed them together, he discovered that 'various paintings had connections to each other through their content. When they were placed together, suddenly a single musical tone passed through them and they became totally different to what they had previously been. A symphony resulted. It was in this way that I began to paint friezes.' Only when they were collected together did Munch recognize that in his paintings the themes of love and death were

repeated like leitmotives, that through them rather than through stylistic consistency his art attained unity and cohesion, and that he could now consciously work towards this by formulating a program for an entire cycle of deliberately related paintings.

Munch's decision to paint a series of paintings should also be seen in relationship to Monet's impressionist series of church façades, haystacks and waterlilies, which were motivated by the empirical recognition that a single painting is incapable of capturing all the nuances of light during a day or during varying atmospheric changes. Munch's representation of love and death through different moments, rather than a single allegorical image, reflects this same empirical concern. In addition, the format of a cycle of paintings or a frieze is also associated traditionally with representations of suprapersonal or supernatural events; most likely, Munch was aware of this association with religious art inherent in a cycle of paintings, and sought to transfer the quality to his own *Frieze of Life*. The same motivation likewise accounts for his experimentation during the mid-1890s with combinations of frieze paintings into triptychs.

In December 1893, Munch rented rooms at Unter den Linden 19 in Berlin for another exhibition. The catalogue listed fifty items, but more than half of these were drawings and watercolors, and several of the paintings were older ones, slightly reworked for the new show. After writing to Rohde in March, Munch had had little time to paint; most of the time had been devoted to traveling throughout Germany and Scandinavia to arrange additional showings of the collection he had brought to Berlin in 1892. August, September and October, however, he spent in Norway and isolated himself from the literary and artistic group, or 'Boheme' as it was called, which usually demanded so much of his attention. It was during these three months that the first paintings of the *Frieze of Life* evolved: seven of the major compositions were completed.

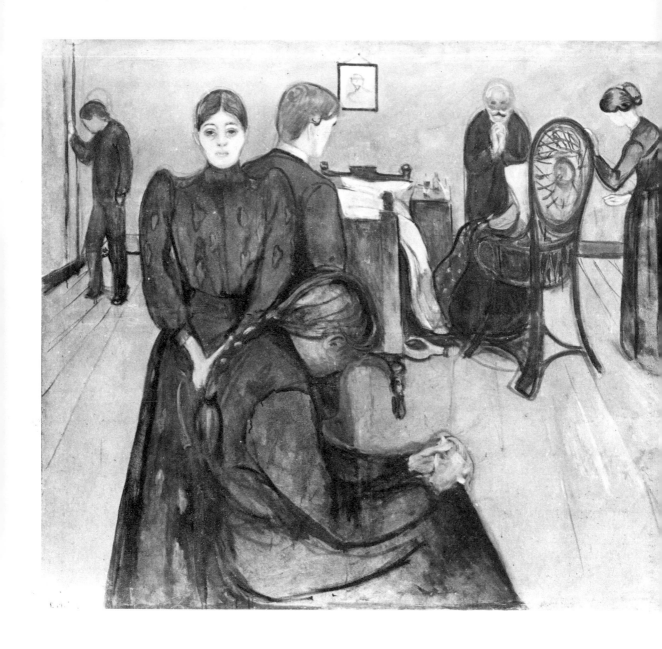

9. *Death in the Sickroom*, E. Munch, 1893

The largest of these, *Death in the Sickroom* [9], greeted the viewer who entered the exhibition; the theme of the dying child was here repeated, but now transformed from a mood of melancholy despair to a study of incommunicability, as each family member reacts to this death, incapable of understanding the phenomenon, incapable of relating his experience to the remaining family. The difference also marks the distinction between the content of Munch's neo-romantic paintings of the 1880s and his work of the 1890s. There was no longer the creation of fine nuances of melancholy feeling, of introspective brooding, but rather the analysis of existential emotional states, of psychologically dramatic experiences. In the *Sick Child*, death was received in resignation, with the light of the sun symbolic of eternal life after death; the mother sat in helpless anticipation and the muted colors of the painting aided in projecting her mood of dejection onto the viewer, but there was no terror as this mood combined with a rather pleasurable feeling of sadness and compassion. In its psychological content, the painting could very well be compared to the numerous Romantic depictions of church ruins. By 1893 this had changed. As in Maeterlinck's *L'Intruse*, death and dying became something nameless, unknowable, recognized only in its actual appearance. In the sickroom, everyone experiences the silent presence of something not usually in their midst, something transforming life itself, a sense of terror forcing each consciousness to withdraw into itself for protection against the intruder. It is biological death, death after God has died, and Munch depicts it, not as it takes possession of the dying, but as the living take possession of death; death is not a supernatural event, but something terrifyingly personal.

Something terrifyingly personal is likewise what Munch found in the powers of love, and these were represented in the remaining six initial paintings of the *Frieze of Life*. Separated from *Death in the Sickroom*, they were hung together under the designation 'Study for a Series: "Love" '. Through them Munch could test the force

of his idea for a cycle of paintings, and they became the nucleus of the completed Frieze, joined by variations and commentaries on the themes they originally expounded. As listed in the catalogue, the six paintings were: *Summer Night's Dream; Kiss; Love and Pain; The Face of the Madonna; Jealousy; Despair* (now called *The Scream*). Using these titles, it is possible to construct a basic narrative plot to unite the series. Love begins during the mid-summer night with dreams of coming love which are followed by the first kiss. The course of love continues, pleasure mingled with pain, attaining its highest intensity in the Madonna face of the loving woman. Finally, love is disrupted by thoughts of jealousy and dies in the moment of despair.

While it may sound like the rejected plot of a nineteenth-century penny novel, this history of love is as closely related to Munch's life and his resulting views of the man-woman relationship as is his characteristic identification of love and death. From his own personal experiences he formulated his conclusions concerning universal human emotions; abstract concepts resulted from specific events subjectively interpreted. It is this abstraction process, combined with its foundation in existential experience, that raises the content of Munch's Frieze above the level of kitsch literature or such anecdotal works as Max Klinger's suite of etchings *A Love* [12-18], which moralistically traced the evolution of a love affair from its inception to the suicide of the girl and the death of her illegitimate child. Rather than telling a piquantly tragic or moralistic story, Munch concentrated his theme of love into a series of select states of consciousness experienced by anonymous but universal personages of a highly neurotic sensitivity as they re-enact the individual psychological dramas of attraction, union, separation and despair.

The erotic experience which he transformed into his series of paintings in 1893 was again a direct product of the bohemian existence Munch had led during the 1880s, the immoral life his father had condemned. Replacing his disapproving father with a

new, more condoning parental image, Munch had become, in the
late eighties, a follower of the Norwegian anarchist writer Hans
Jæger [10], leader of the revolutionary group of artists and writers
calling themselves the Kristiania Boheme. Revolutionary, anarchist,
determinist and advocate of free love, Jæger openly attacked
society and its 'three gargantuan idols: Christianity, morality and
the old legal codes'.[12] In Kristiania during the 1880s, where over
half the population was under twenty-three years of age, Jæger's

10. *Hans Jæger*. E. Munch, 1889

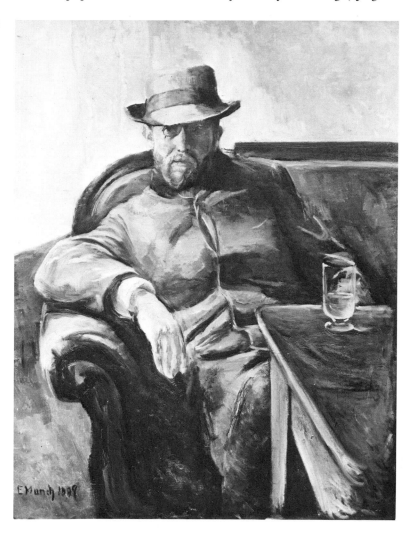

teachings naturally found enthusiastic adherents among the young, those whose sexual curiosity had attained its greatest intensity as they were passing through the years of puberty. Included was Munch, who was then pursuing someone else's wife. But Munch soon recognized the weakness of Jæger's system of free love. The weakness was jealousy.

The woman Munch called 'Fru Heiberg' in his fictionalized diaries was the wife of a naval medical officer and was three years older than the painter; his affair with her appears to have lasted six years, until he went to Paris in 1889. For their first meeting, she had invited him to come to her, and the initial rendezvous was followed by numerous others in streets and forests, in cafés and in Munch's studio. But there was always the shadow of her husband and other lovers haunting Munch:

'What would you say if I were to come to you?' she said, and glanced at him. They both smiled. He saw her coming in her white linen slip, closed eyes and bare legs, and the thoughts gave him pleasure.

After a while she said, 'My position is really good. Because I have no children I can do whatever I like.' Suddenly he thought of the husband; he had almost forgotten that she was married, and the thought came as a shock to him. 'But what of your husband?' 'Oh, him. He doesn't care what I do. I have my free will in everything.'

It was the position of Jæger's liberated bohemian woman, free to do as she wills, not chained by marriage but rather freed through it from society's sexual limitations; were she single, the law would have forced her into the role of a prostitute like the heroine of Christian Krohg's novel *Albertine*. His strict Christian upbringing prevented Munch from being as much at ease about the husband as was 'Fru Heiberg'; he could even sympathize with him: 'How many times have you been alone at home in the evenings and waited for your wife, listened for her footsteps? She told you she was going to her friend, but she never visited her really. And so she was with me, embracing me fervently . . . But suspicion and jealousy have tortured you and have eaten at the roots of your heart.' When

he was ill in St Cloud in February 1890, Munch thought of her and of the significance she had in his life:

It's been a long time since I last thought about her, but still the feeling is there. What a deep mark she has left in my heart! No other picture can ever totally replace hers.

Is it because she was beautiful? No, I'm not even sure she was pretty; her mouth was big. She could even be repulsive . . . Is it because we agreed in our views and opinions? We actually did not even know each other. And yet –

Is it because she took my first kiss that she took the perfume of life from me? Is it because she lied, deceived, that one day she suddenly took the blinkers from my eyes and I saw her Medusa head, saw life as a great puzzle? Everything which previously was rosy hued now became empty and grey.

The love to which he had thrilled, living in the turmoil of its erotic pleasures, had been destructive in its results, leaving only a hollow sense of emptiness and disgust, draining all hope from life. This was the ultimate consequence of man's love for a woman.

This pessimistic conclusion was borne out by Munch's observation of other loves among the Kristiania Boheme, such as the one Hans Jæger had intended as living support for the truth of his theories of free love and recorded in his autobiographical novels *Perverted Love* and *Prison and Despair*.[13]

And despairing jealousy became the basic ingredient of Jæger's experiment in free love as revealed by Munch in his aquatint and dry-point engraving *From the Kristiania Boheme II* [11]. Seated around a long table in a dark, smoke-filled interior are six men; in the background, before a curtained window, stands a young woman, her hands on her hips. Only the heavy, mustached man in the foreground has a glass in front of him and is drinking the contents of the bottle placed on the table; it is this detail, that he alone is concerned with tangible objects, that separates this composition from depictions of bohemian drinking bouts. It is this man, who stares directly out of the picture and in no way com-

municates with the others, who is the sole, actual, physical presence
in Munch's print; the others, who appear around the table, are the
shadowy appearances of his thoughts, from left to right: Munch
himself, Christian Krohg, the journalist Jappe Nilssen, Hans
Jæger staring adoringly up at his bohemian love, and the playwright

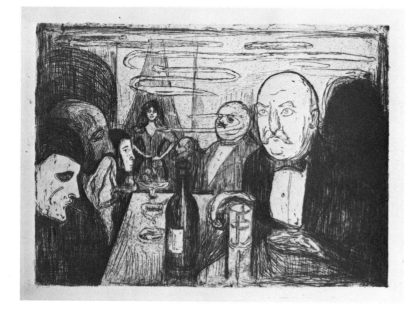

11. *From the Kristiania Boheme II.*
E. Munch, 1895

Gunnar Heiberg. The drinker in the foreground is the emancipated
woman's first husband, now surrounded by his jealous visions of
her as she triumphantly parades her charms for the continuous
chain of her new loves.[14] The woman belongs to none of them and
all of them belong to her, and the sole products of her love were
thoughts of suicide and tormented jealousy and hopeless despair.

In the free love of the Kristiania Boheme, woman revealed one
aspect of her nature to Munch. Through her physical charms, she
brought about the weakening and enslavement of man in his love
for her, but this love was transformed by her lies and deception
into jealousy and despair, what Søren Kierkegaard defined as the
sickness leading to death. In this relationship, woman was destruc-

tive, death-bringing for man; Munch viewed her as 'the whore who at all times of the day and night seeks to outwit man, to cause his fall'. But he saw another aspect of woman as well: 'Woman is the earth, anxious, always waiting to be inseminated if man is willing. She is anxious for the insemination to take place at the proper time, and anxious to have the seed grow.' This was woman offering herself for the life of a child, the Madonna serving as the link in the chain of generations. It was woman as his mother had revealed her to Munch, woman entering death to bring life. If despair, the hopeless state of spiritual death, could be brought to man by woman's conquest, she sacrificed herself to physical death in the child born of her erotic conquest. Love therefore brought death to both partners, but to man it was the death of spiritual defeat while to woman it was the death of the life-giving heroine.

The loves of the Kristiania Boheme, the numerous affairs of his friends as well as his own as Munch observed them, bore no fruit since the physical generation of a child was rejected. Only after they were freed of their experiments in free love were its adherents able to make it productive, but in a spiritual rather than physical manner. He did not alter society through free love, but after he was liberated from it, Jæger could translate his perverted love into an erotic poetry of despair. Similarly, it was necessary for Munch to be freed from the Kristiania Boheme's philosophy of love before he could formulate his own and paint his visions of eros, of woman's nature, and of love's relationship to death. Hans Jæger had formulated the dictum that a writer write only his own biography; to Munch he left the advice to paint his own life, and Munch formulated it into 'I paint, not what I see, but what I saw'. This was the content of his new monumental art; subjective psychological experiences, raised to the level of universal statements analyzing the soul of modern man – replacing the drama of Greek epics, the drama of history which Lessing had still seen as the artist's source of inspiration. Introspection replaced external inspiration.

2. Love

 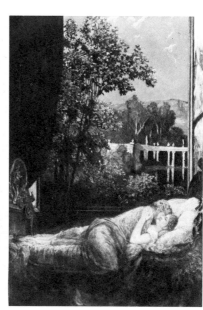

From the title page of Max Klinger's *Eine Liebe*, a nude Eros, surrounded by centauresses and seated on a huge rock overlooking a dramatically raging ocean, shoots an arrow which will determine the fate of the two lovers whose story is to be told. It is this source, the god of fleshly, passionate love, that rules the entire evolution of the love affair that begins at the park gate on a hot summer afternoon when shutters are drawn on all the houses. As the woman, fashionably dressed with a straw hat, is about to enter the gate, a man hands her a rose and rushes to kiss her hand [12]. The following scene shows the two lovers secretly embracing [13]; as they become

one, nightingales sing, perhaps ominously, in the moonlit garden seen through the open window, at the moment of the lovers' greatest bliss [14]. But a winged demon comes, pulls the covers from them and in a mirror they see themselves naked, their passions sated; the man gasps as he recognizes himself and her as what they really are, floating in nothingness, without support over a deep abyss, and the woman clings fast to him, a dead weight unwilling to admit the reality of anything but him [15]. He flees, and

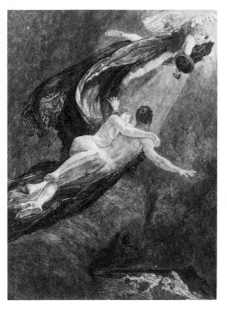
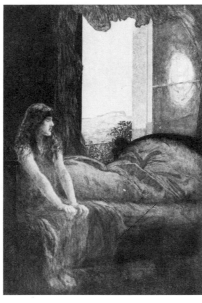

12. *Meeting at the Gate*
13. *Kiss*
14. *Embrace*
15. *Intermezzo*
16. *A Vision*
17. *Shame*
M. Klinger, 1887

in sleepless nights she sees the reflection of the moonlight on the windowpane transform itself into the vision of an unborn child in her womb [16]. She sees herself aged and sulking along a bare white wall which reflects the shadow of her pregnant figure; people stare mockingly while at her side, wearing the straw hat she had worn at the first rendezvous, walks a taunting, pointing demon [17]. The final scene shows the reward of her immorality; she lies stretched out on a bier, dead, while the man, now filled with remorse, weeps and holds her head; in the background, a figure in a wide black coat carries the limp small form of the dead child

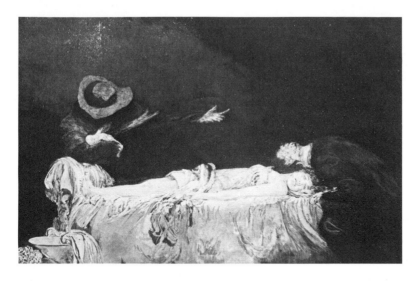

18. *Finale*. M. Klinger, 1887

and beckons with an emaciated white hand for the man to follow, to follow the only path where he will again find peace of mind [18].

Death becomes the ultimate victor in this, as well as most other graphic cycles by Klinger; it is a deep-seated Schopenhauerian pessimism likewise shared by Munch. The difference between the two artists appears in the means of expression, in the way they coordinate form and content. Both Munch and Klinger were trained in the mores of Naturalism, in the total dependence on observation and visual reality; both artists sought to overcome this by turning to symbolist imagery, and for both of them this new content forced changes in stylistic vocabulary, an adjustment and partial rejection of their naturalist training. In Munch's development, perhaps in part because he already had Klinger's example with which to compete, this adjustment was the more radical and pointed towards the future, towards Kirchner, Nolde or Kandinsky, whereas Klinger remained tied to the past, a reflection of Böcklin and academic values abstracted from fifteenth-century Italy and Michelangelo.

Both Munch and Klinger form part of the general trend towards an art of subjective content which emerged in Continental Europe

during the 1880s, a neo-romantic tendency which had its direct pictorial sources in Arnold Böcklin, and Gustave Moreau, and in the late Romantic paintings of the English Pre-Raphaelites. Often the painters were closely associated and identified with similar tendencies in literature, so that the term 'symbolist', originally used to describe the writings of Mallarmé, Verlaine, Huysmans and other French poets associated with them, is now generally applied to the painters as well. However, precisely who the symbolist artists of the fin-de-siècle were and what the characteristics are that unite them is a question still lacking a definitive answer. The exhibitors of the Rose + Croix salons, Gauguin and the Nabis, Jan Toorop and Fernand Khnopff are perhaps the artists most commonly identified as Symbolists, and Munch shares many of their artistic convictions. Primary in symbolist teachings is that the painting should represent a reality beyond itself, that it should convey a spiritual or religious meaning and that therefore the image need not be a true reflection of its material model, that the content of painting is not dependent on visible reality. This concern with a spiritual content and the didactic value of art in turn fostered the close relationship with, and often the direct dependence on, literature. Both the subjective anti-realist attitude and the fascination with literary values form basic elements of Munch's art. His admiration for Arnold Böcklin and his attempt, in 1896,[15] to meet Fernand Khnopff likewise argue for the inclusion of Munch among a list of symbolist painters. Despite this, his position within the amorphous Symbolist Movement is not easily clarified; like Gauguin, he participated in it and shared many of its values and yet remained distinctly separate, perhaps most clearly in his radical proto-expressionist formal vocabulary.[16] In a sketchbook used between 1890 and 1894, Munch provided a definition which can serve to illustrate his ambivalent attitude: '*Symbolismen – Naturen formes efter ens Sindstemning.*' (Symbolism – Nature is molded according to your subjective mood.) It is a definition which retains a strong emphasis on the natural model and appears essentially as a

paraphrase of Zola's famous definition of art as nature seen through a temperament. However, Munch not only sees nature but also deliberately manipulates and distorts its features in order to meet the essential purpose of expressing or symbolizing a psychological state, the mood of his soul. Unlike Klinger or other symbolists, he seldom uses individual objects within a composition as isolated symbols of another reality, but rather transforms the entire painting into an existential symbol.

Klinger's symbolism is an eclectic one forced onto a naturalistic vocabulary and combined with the imitation of older forms in modern dress. Symbols of Greek history and mythology are resurrected to appear in the interiors and cities of the German *Gründerzeit*. Karl Scheffler characterized him as an 'atelier genius', whose works never totally rid themselves of the cold aura of museum antiquity. The ideas behind his works, the allegories of a grandly conceived philosophy of life, subordinate the imagery so that a narration of the content reveals more to the viewer than repeated analysis of the image itself. It is perhaps this absolute dependence on literary, verbally translatable content that separates Klinger from Munch for us today, while at the same time explaining Klinger's immense success at the turn of the century. Klinger revealed his sources, his contemplation of nineteenth-century German moral thought from Hegel to Nietzsche; his imagery formed an exact one-to-one equation with the written beliefs of his time and could therefore be appreciated by a broadly based audience. In contrast, Munch's imagery originated with the artist's own subjective experiences and as a result, no matter how universal the subject matter of love might be, received a totally personal coloration and context unshared by others. The problem for Munch was not so much how to embody a thoroughly defined *Weltanschauung*, but rather how to communicate the universal aspects of his own totally subjective beliefs and memories. Form and iconography therefore were not predetermined, as in Klinger, but rather were adopted and adapted to express as succinctly as possible a non-specific, sub-

jective content resulting from states of conscious existence rather than moralistic messages. Partially as a result of this, likewise, the narrative content of Munch's series is far more simple, or even simplistic, than Klinger's *Eine Liebe,* but the individual images as well as total meaning become more complex and analytically rich.

Personal memories formed the source of Munch's series 'Love', but the memories lost their specificity and personal quality when he translated them into pictorial symbols of all love. The first painting of Munch's series [19] shows a young girl, clothed in white, standing

19. *The Voice*
(Summer Night's Dream).
E. Munch, 1893

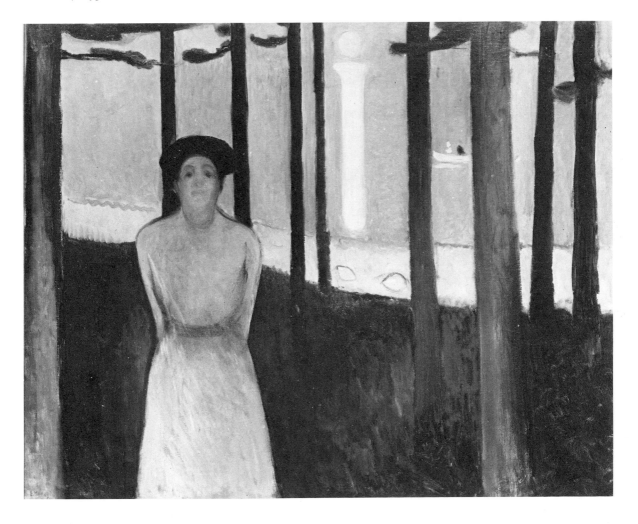

alone in a forest with a view of a seashore and the reflection of the
moon on the water behind her; there is none of Klinger's anecdotal
concern, but rather once again the representation of a mood, of
quiet expectation. Now generally known as *The Voice*, the painting
was originally entitled *Summer Night's Dream* and its meaning was
indicated by the critic Franz Servaes writing after consultation with
Munch: 'Munch shows us the recently matured girl as she has her
"Summer Night's Dream"; i.e., how the sexual will rises stiffly for
her for the first time during a pale moonlit night, and how the girl
roves longingly among the trees, her hands cramped together behind
her, her head tossed back, and her eyes staring wide and vampire-
like'.[17] The completion of the painting is in the eyes of the viewer;
it is at him that the girl stares temptingly as she feels the physical
changes and desires of puberty. The viewer is her first suitor.

Both in the setting and in the pose of the girl Munch clarifies his
meaning of the painting. The forest and shores of the fjord are
traditionally the meeting places of Norwegian lovers, and the mid-
summer night is the time of courtships. The pose of the girl was
consistently used by Munch to symbolize woman's presentation of
herself to man. With her arms behind her back, she forces her breasts
forward while her lifted head raises them. Similarly, placing the
hands behind the body leaves it free to be displayed and touched, a
sense of openness in contrast to the sense of closure and protection
given when the hands appear in front. But at the same time, having
one's arms behind one's back is an evasive gesture preventing acts
such as the ready return of an embrace. Through her pose Munch
represents the pubescent girl as engaged in both sexual self-display
and doubtful withdrawal, characteristic of the adolescent's first
reactions to her awakening sexual appetites.

The first sexual experience is *The Kiss* [20]. In a darkened room,
crowded beside a brightly lit window, two lovers embrace, a situation
which easily could be a slightly erotic genre scene but which Munch
transformed into a statement on the loss of individuality in an erotic
act. Przybyszewski recognized this when he saw in the painting,

20. *The Kiss*. E. Munch, 1892

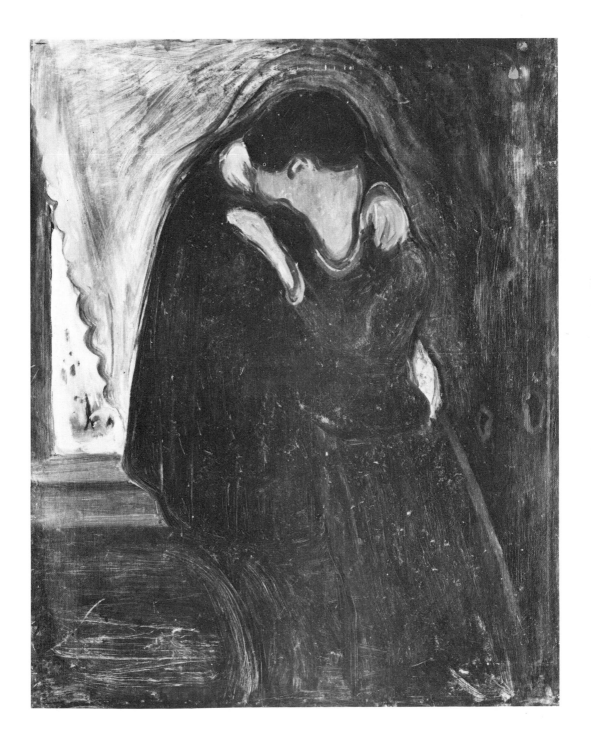

two human forms whose faces have melted together. No single identifying feature remains; we only see the area where they all melted together, and this looks like a giant ear gone deaf in the ecstasy of the blood. It looks like a puddle of melted flesh; there is something repulsive about it. Certainly this type of symbolization is unusual; but the entire passion of the kiss, the terrible power of painful sexual desire, the disappearance of personal consciousness, that melting together of two naked individualities – all this is so honestly represented that we must overlook the repulsive and unusual aspects of it.[18]

The painting is one which Munch worked out in a number of sketches and studies, seeking to attain a clear expression of this loss of individuality, and finally arriving at the solution of renouncing facial features and melting the two figures together into a single form. Munch's *Kiss* is a kiss without lips and an embrace without limbs, an act of spiritual and physical contact ironically depicted without contact features as it characterizes the essential erotic sensation of feeling the reality of the other. For Munch, this was possible to such a degree of intensity that his own ego-consciousness became less significant than the recognition of the encroaching ego of his partner. Man and woman, engaged in an erotic act, became pulled into an ego-dissolving experience as they were 'in-corporated' into the corporal and psychological reality of the other. For Munch, this was an experience culminating in fear, fear of the reality of the other, and ultimately fear of the opposite sex.

In this context, *The Kiss* can be read as a triptych of fears. On the left, the window with its sharp break into light and space contrasts with the flatness of the enclosing wall and the soft, protective darkness of the interior. The window, the light and the environment are viewed as destructive threats against which the figures must be protected by the heavy wall-outlines of their form as well as by the 'force-lines' which emanate from them as cushions against direct contact with the surrounding area. In the center of the painting are the embracing figures who demonstrate the fear of the other, of losing one's individuality to another. The final fear is to the right of the figures, the right-hand panel of this 'triptych of fears', a dark

flat area against which the silhouette of the woman presents no protective outline-wall and which shares her coloration. In this area appear red forms of spermatozoa and, at the top of the painting, the vague, red form of an embryo. Once again, the presence of 'an other' is to be feared: the growth and birth of a child endangers the life of the woman. Unlike that love-hatred which Przybyszewski or August Strindberg had towards woman, Munch's view could be both positive and negative: in the role of a mother he saw her as heroically willing to court death to bring life, but as man's sexual partner she became a constant threat to his own existence.

Similarly illustrative of the ego-destroying powers of physical love is *Love and Pain*, now known as *The Vampire* [21], the title given it by Przybyszewski. As in his *stemnings* paintings of the 1880s, Munch here generates a mood primarily through color rather than composition. Applied in a feathery, quasi-impressionist facture commonly used by Munch in 1893 is what Franz Servaes described as 'a specifically Munchean dark blue-violet . . . his beloved mystical deep blue'. This shade of blue, an unforgettable one defying both description and photography, with its broken facture, lends the painting a mysterious, insubstantial quality, appearing almost like a living fluidum which encompasses the figures. The figures themselves evolve from this engulfing environment; lacking true contours, they seem alternately to appear and disappear in a spotlight effect which picks out their arms, faces, and the golden red of the woman's hair from the surrounding melancholy blue. The only truly solid form in the painting is the dark shadow lurking menacingly behind the amorphous shape of the woman kissing the nape of the man's neck.

Although the mythical vampires of Romantic Gothic tales were consistently male, by the end of the nineteenth century vampires usually took on female form. The destructive, death-bringing woman appeared in writings by Gautier, Barbey d'Aurevilly and Munch's friends Przybyszewski and Strindberg. The playwright with whom Munch identified most, Henrik Ibsen, likewise cast

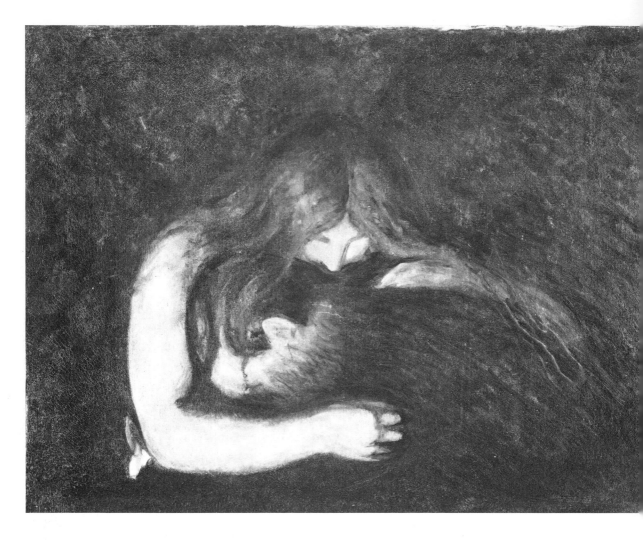

woman as a murderous personality and a life-destroying, vampirous
figure in *Hedda Gabler* (1890). But the title *Vampire* in many ways
falsifies the meaning Munch originally intended for his painting,
something he himself recognized and sought to counteract. In the
painting there is nothing of the blood-sucking, physical vampirism,
but rather woman appears as a heavy weight bearing down on man,
hanging onto him with the painful and binding grip of her love. The
carnal love brought to man by woman is a burdensome pain capable

21. *The Vampire (Love and Pain).*
E. Munch, *c.* 1893-4

22 *(right). The Madonna.*
E. Munch, *c.* 1893

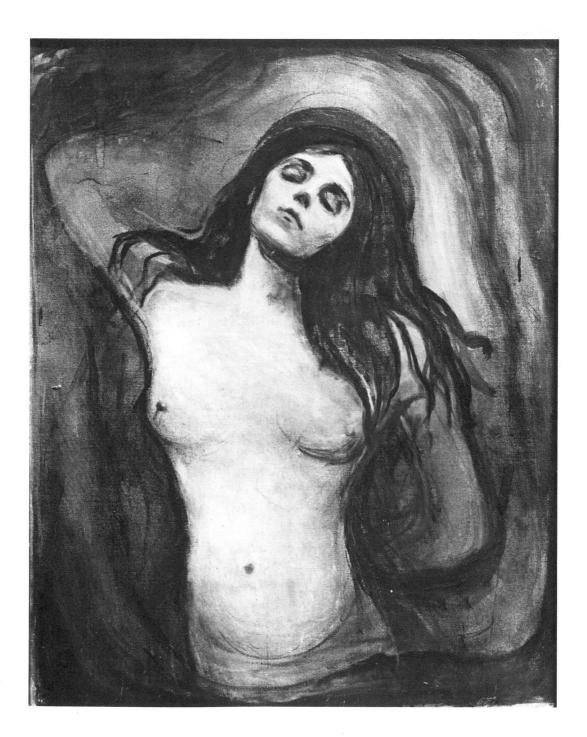

of destroying his creative powers and his personal existence; the love of woman is equated with a spiritual, not physical, death. It is the jealous, suicidal, despairing love of the Kristiania Boheme.

But, as already noted, Munch did not solely see danger and destruction in woman; her subordination of man in love had as its purpose her own insemination and the ultimate life of a child. It is this theme, first stated in *The Kiss*, which he developed more fully in *The Madonna* [22], a painting of which he made a total of five versions as well as lithographs and a dry point engraving. Using as a model the wife of Stanislaw Przybyszewski, or possibly her recently married sister, Munch depicts a nude woman, one arm held behind her back and the other raised to her head which she has thrown back and turned slightly while her eyes close and her mouth opens in a sigh; around this head with its expanse of loosely falling black hair appears a deep red halo. Seen frontally in the ecstasy of love, she again has as her partner the viewer, as in *The Voice*.

The body of the 'Madonna' is naturalistically rendered, appearing as a very definite three-dimensional form against a flat, abstract background whose configuration echoes her silhouette but also takes on the shape of a womb. The colors, fading from a bright red-orange in the lower right, are applied very thinly so that the white undercoating as well as the grain of the canvas shimmer through. The extremely thin quality of the paint resulted in drips in parts of the work, and Munch permitted these controlled accidental appearances to remain in his finished painting. Like the visible retention of changes in other paintings by him, these drips are intended to leave the impression that the artist created during a fit of passion, almost unconsciously, instinctively and directly without prior thought or study. Although he had made numerous preliminary studies for the painting, Munch worked out the final composition on the canvas, making decisions as he was working and retaining the charcoal drawing, erasures and corrections of this working process in the completed composition. In his *Madonna* and in other paintings of

1893, through the drips and other signs of the artist's working process, an aesthetic of the accidental mark and of the subconscious workings of the artist's mind asserted itself. Munch's positive aesthetic appreciation of the accidental, foreshadowing similar theories of twentieth-century art, most notably Surrealism and Abstract Expressionism, was likewise shared by August Strindberg who published an article entitled 'On Chance in Artistic Production' in 1894 in the *Revue des Revues* formulating a theory of 'art automatique' in which the artist would work through a 'charming mixture of conscious and unconscious creation'.

The drips, the thin paint, and the retention of the charcoal drawing likewise have the effect of emphasizing the flatness of the canvas in a way reminiscent of contemporary paintings by Gauguin and the Nabis. But the melting together of the colors, as well as the fading of the Madonna's arms into the background area, tend also to create a sense of liquid space, a type of fluid environment similar to that of *The Vampire* and containing the womb-like form within which the Madonna hovers. In contrast to this appears the carefully rendered, illusionistically three-dimensional shape of the nude herself so that a strong dichotomy of flat surface and vague space, of the canvas plane and plastic form is attained, an effect Munch had first introduced to his art in the summer of 1889 before going to Paris.

The pose of his Madonna, with one arm raised behind her head and the other held behind her back, is one Munch could have seen numerous models holding while he studied figure drawing in Bonnat's studio in Paris. It is a common nineteenth-century beauty pose, but it is also that of the well-known Greek Classical sculpture of a dying Niobid; the pose therefore becomes one symbolizing Munch's view of his Madonna with 'a corpse's smile' at the moment of conception as 'life shakes the hand of death'. This gruesome view of the act of love as approaching death was clarified further by Munch in the frame with which he originally surrounded the painting. All that remains of it today is a few strokes of red paint along the edge of the

painting, but Munch included the frame on his lithograph version of
the motif [23]. On the red frame he painted sperm completely sur-
rounding the image of the Madonna while in the lower left corner
crouched a small skeleton-like embryo, again a visualization of this
interpenetration of life and death in the inception of a child. Birth
and death, like love and death, were mutually dependent and always
appeared together, and woman was a creature dominated by death,
endangering not only man but herself as well.

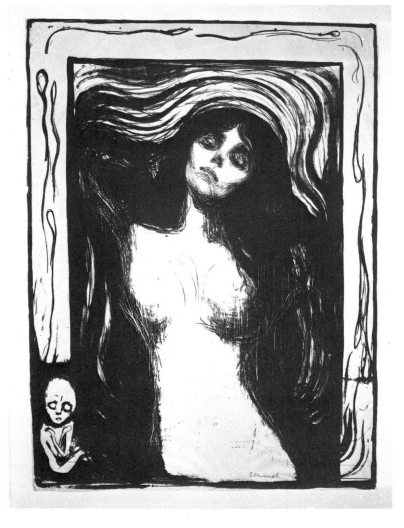

23. *The Madonna.*
E. Munch, 1896-1902

In the conception of love Munch brought from his experiences in the Kristiania Boheme, jealousy followed consummation. The painting Munch created in 1893 [24] evolved directly from a depiction of *Melancholy* of 1891, a painting he had reworked into a number of sketches to serve as the frontispiece for a collection of poems by Emanuel Goldstein. Jealousy is embodied in a landscape, the shores of the Oslofjord at Aasgaardstrand where Munch spent his summers in the company of the Kristiania Boheme. Facing away from this

24. Jealousy.
E. Munch, 1893

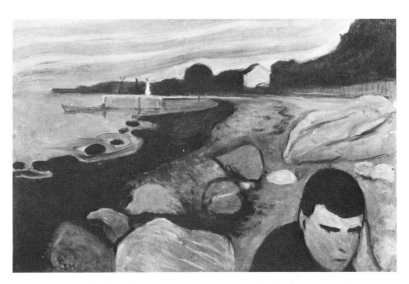

grey, depressing landscape, in the lower right foreground, is a man, apparently seated with his head propped on his left hand. His back is turned to the scene taking place in the center of the landscape: a man and a woman stand on a pier and prepare to enter a boat. In its emphasis on outlines and silhouettes, in a dichotomy of flattened shapes and spatial projection, and in the contrasting uses of thinned and impasto paint, *Jealousy* once again represents Munch's stylistic concerns of the early 1890s.

Przybyszewski described the scene as

. . . a landscape with heavy-handed contours depicted in a simple-minded, dull chiaroscuro. Close to the front, just as in Chinese paintings, we see a man's head peering out from the frame with an eye shaped like a triangle;

a symbol for the eternity of one of the most banal and agonizing emotions. This painting embodies all that stupid, inflexible brooding of passion reversed into the insane idiocy of despair. Almost like a pictorial present- ation of Cicisbeo's physiological experiment of light and color sensations, the painting is nothing more than the visualization of the suffering felt in natural selection . . . This is the way that a landscape is pictured in the mind of a male who has lost a female he had chosen to someone else: the wild, prehistoric battle for the female has been transformed into a cultured, *triste*, cowardly, resigned brooding.[19]

While this description is deeply colored by Przybyszewski's own 'pathological eroticism', it is also indicative of the degree to which Munch was concerned with the psychology, and not the events of jealousy. It is not the little scene in the center background that gives the painting its meaning, but rather the over-all poisonously grey *stemning* combined with the brooding stare of the foreground figure. This stare out of the painting divorces the figure from the scene around it and his flattened, heavily outlined form enhances this divorce in its sharp contrast to the seashore moving into depth. Spatially located on the picture plane itself and at the extreme edge of the painting, he exists in a different formal order of existence as the landscape behind him is transformed from a setting of place into a state of psychological consciousness, into a visual representation of his thoughts of jealousy exactly as in the engraving *From the Kristiania Boheme* [11].

In the final painting of the series 'Love', Munch again reiterated his conviction that love and death were closely connected, that in love or in being loved one is acutely threatened. But *The Scream* [25] forms an even more precise personal confession of schizoid fears, and is even more closely tied to specific events of Munch's life and psychological development, while at the same time the painting reveals his intense need to communicate through his work and find the understanding of a compassionate audience. Through his paint- ings, Munch at one and the same time attempted to retreat pro- tectively into the reality of his own existence and totally to reveal the precarious existential state of his personality.

25. *The Scream*. E. Munch, 1893

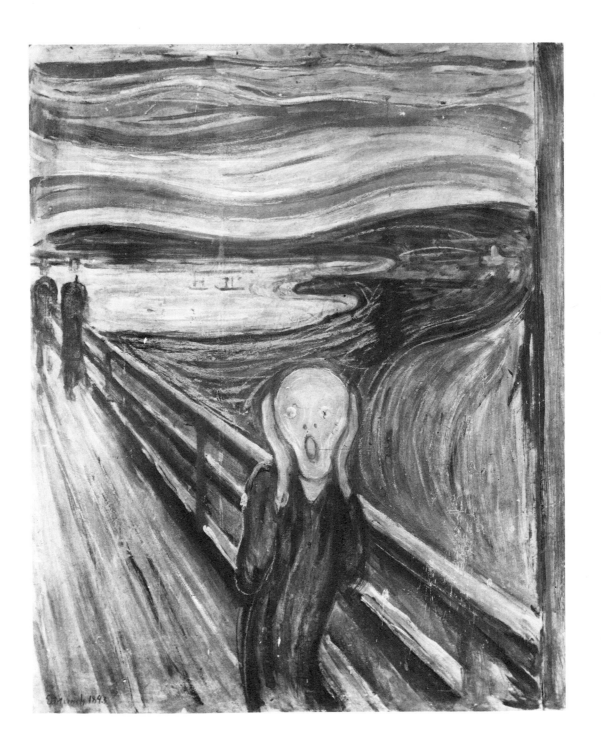

3. The Path of Death

Between 1890 and 1893, Munch made several similar drawings of a single motif: on an empty road is the lonely figure of an old man walking, his head and shoulders hunched forward, his arms limp at his side. The representation of the single figure seen from the back, slowly moving into the vast space of an unpopulated landscape derived from the Romantic formulations of Friedrich's works, as Munch had already used them in 1888 in *Evening: Loneliness* [6], but in these drawings the landscape shows no life whatsoever, no green trees, no moonlight, no houses, and Munch's insistent repetition of the image indicates that it must have meant more to him than the neo-romantic melancholy of the earlier paintings.

The first of these drawings appears on the same type of paper as the letter Munch wrote from Paris on 7 December 1889 to his sisters Laura and Inger about his reaction to his father's death. And in his private notes Munch returned to the contemplation of this death. His intense melancholy and despair during the early months of 1890 had its roots in two causes: one, the personal sense of extreme grief and remorse felt after the death of Dr Christian Munch; the other, the rejection of Jæger's denial of an afterlife. Still convinced that Christianity did not provide the proper answers, Munch entered into a time of intense renewed questioning about the nature of life and death and about the problem of life after or in death. The father image and authoritarian position which Hans Jæger had assumed during Munch's life in the Kristiania Boheme gave way to a new idealized image of the father himself as a generator, life-source and protector of the Munch family.

This third death in the family now became the most significant one and the experience had to be given a pictorial form, had to

be brought under the control of what was visual. His naturalist aesthetic bias limited Munch to depicting his father as he had experienced him, alive rather than dead or dying, but at the same time Munch intended the work to be a memorial to the dead. His depiction had to clarify that life had been transformed into a memory, into changeless death. The man on the endless, barren road was one solution which answered the dual demands.

The Norwegian realists, like the German painter Wilhelm Leibl, had devoted many of their canvases to representations of peasants. This interest in national folklore, an interest continuing from the Romantics, found expression during the 1880s and 1890s not only in the careful depictions of peasant costumes and life but also in illustrations and paintings by Erik Werenskiold, Christian Skredsvig, Gerhard Munthe and Theodor Kittelsen, who sought their inspiration in Norwegian folk tales and folksongs. Munch's empty landscapes with the long road leading through them have a similar source in Norwegian idiomatic expressions. The drawings literally depict a man who *vandrer den vei som ikke vender tilbake* (walks down the path from which there is no return). It is an expression in which the endless road and barren flat landscape represent the image of death.[20]

The drawings are allegories of Dr Munch's death, with the figure taking on not only the physical characteristics of the father, but also of Hans Jæger and of Christian Krohg, Munch's teacher and mentor. In such a wider identification, Munch created not only a memorial to his father, but also a statement of his own independence from the authorities that had ruled his past. His father could no longer torment Munch with his religious hypersensitivity; Hans Jæger's principles of free love and rejection of an afterlife had failed him; and Christian Krohg's stylistic and thematic concerns were no longer his. From these physical and spiritual deaths, Munch gained the new life of his personal art.

If the drawing of 1890 is compared to that of 1893, a significant difference is noticeable. Although the figure casts no shadow, the

pen drawing of 1890 [26] is basically a somewhat simplified naturalist genre scene, much like the representations of family scenes appearing on the reverse of the drawing. The wide, empty road curves easily back towards the horizon in freely rendered linear perspective. In contrast, the drawing of 1893 [27] divides the page into flat areas dominated by the exaggerated, piercing motion of the straight road into depth, a manneristic perspective which separates this representation from Munch's earlier naturalistic drawing. It was a device borrowed from the works of Vincent Van Gogh and Émile Bernard.

26. *Allegory of Death.*
E. Munch, *c.* 1890

27. *Allegory of Death.*
E. Munch, *c.* 1893

On 25 April 1891, Munch wrote home that he had arrived in Paris from Nice and was visiting the Salons before catching the ship on which he would return to Kristiania. The future evolution of his painting indicates that Munch must have found little of interest in the official Salon, but that the Salon des Indépendants, which closed two days after he arrived in Paris, proved an exciting and extremely significant experience for him. Perhaps he was first attracted to the Indépendants by the work of Jens Ferdinand Willumsen, a Danish painter also befriended by Johan Rohde.

28. Road with Cypress and Star.
Van Gogh, 1890

Willumsen exhibited ten paintings, sculptures and prints strongly influenced by Gauguin and Toulouse-Lautrec. But more significant to Munch was the memorial exhibition of ten paintings by Van Gogh, about whom he had heard from both Rohde and Christian Skredsvig. It was among Van Gogh's depictions of cypresses [28] and the streets of Arles that Munch found the perspective devices he later used in the memorial drawings of his father.

Van Gogh's sharp perspective was immediately adopted by Munch in a painting of the Rue Lafayette as he saw it from the balcony of his room [29]. Completed before Munch returned to Norway on 29 May, this painting however also demonstrates other impressions he received of contemporary French painting and his ability to adapt its techniques to his own purposes. The broken, blurring brushstrokes of the painting derive directly from the numerous neo-impressionist works displayed at the Indépendants by Seurat and his followers, but Munch used the pointillist technique not to gain greater luminosity or color harmony, but rather to lend the scene the subjective impression of the speed and motion proper to a city street. The moving blurs of horse-drawn carriages and taxis, the rushing movement of crowds of people, the sharp Van Gogh-like perspective line of the balcony railing, and the single isolated stable figure of the man leaning on the railing acting as a contrast and accent to the movement in the street: all devices and elements of the composition serve the single purpose of rendering the mobile life of the modern city, much as the Italian Futurists did twenty years later. This unique attraction to the expression of motion contrasts sharply with the original uses of the pointillist technique in Seurat's calm, precise renderings of Sunday strollers or studio interiors. Similarly, the Van Gogh-derived sharpness of perspective space lacks the tension and obsession which the Dutch painter imparted to it, and becomes transformed into a diagonal pattern of motion and speed.

The streets of Paris had served previously as the motif of painters such as Monet or Pissarro, who likewise represented the spectacle

29. *Rue Lafayette*. E. Munch, 1891

of the city as seen from balconies or from upper-story windows. In Norway, Christian Krohg and Frits Thaulow adopted this French impressionist motif for the recording of street scenes of the Norwegian capital city. Munch continued in this tradition, but while the previous painters had, like a photograph, transformed the urban motion into frozen still-life, he retained the city's visual life. But Munch's relationship to contemporary French art is more complicated than this analysis of the Rue Lafayette painting has so far indicated. While the composition Munch uses could be little more than an accident of actual vision – the artist on the balcony with a friend looking down onto the street, and this scene then simply painted as seen and experienced – the painting is a nearly exact duplication, in reverse, of Gustave Caillebotte's *Homme au balcon* [30], which even presents, although in a more limited way, some sense of the movement taking place in the street. It is not known whether Munch ever knew either Caillebotte or his paintings, but his somewhat conservative adoption of Impressionism as well as his habitual use of exaggerated perspective in his representations of city streets are both characteristics which would have appealed to Munch quite strongly at a time when he was searching not only for a personal style, but more exactly for a personal style which would find approval from his public in much the same manner as Caillebotte's 'pre-impressionist' compositions were accepted by the Parisian public of the 1880s.[21] There remained constantly in Munch the dual desire to be popularly accepted and to be an artist of his own time, using the vocabularies which his contemporaries were developing but using them in a manner which retained the reminiscences of tradition.

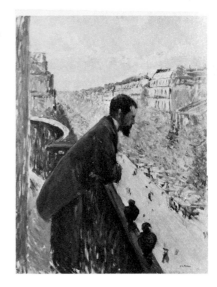

Van Gogh's and Caillebotte's perspective was transformed into messages of motion in the painting of the Rue Lafayette; in the 1893 drawing of Munch's father, it was adapted as a formula for death. The diagonal road piercing the depths reappears in one of Munch's sketchbooks [31], but now the setting is neither the barren scene of death nor the vitality of city life, but a railing along a

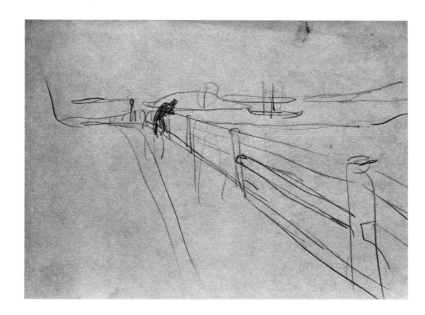

30. *Homme au balcon.*
G. Caillebotte, 1880

31 *(right).* Study for *Despair.*
E. Munch, *c.* 1891-2

deserted street overlooking a body of water on which is a single ship; leaning on the railing, much as in the Rue Lafayette painting, is the isolated figure of a man wearing a top hat. The scene is one Munch described in a diary entry from 22 January, 1892 (see Appendix I, p. 103), written while he was in Nice but recording an event which had taken place in Norway:

I was walking along the road with two friends. The sun set. I felt a tinge of melancholy. Suddenly the sky became a bloody red.

I stopped, leaned against the railing, dead tired, and I looked at the flaming clouds that hung like blood and a sword over the blue-black fjord and the city.

My friends walked on. I stood there, trembling with fright. And I felt a loud, unending scream piercing nature.

Like the deaths in his family, this was an experience Munch felt he had to bring to terms visually in a painting, to bring to this irrational, psychotic experience the tight control and mastery of his artistic talent so as to be able to communicate it to others. The process was, however, an extremely difficult one for him, as

Christian Skredsvig recorded in his memories of Munch in Nice in 1892:

For some time Munch had been wanting to paint the memory of a sunset. Red as blood. No, it actually *was* coagulated blood. But not a single other person would see it the same way as he had; they would all see nothing but clouds. He talked himself sick about that sunset and about how it had filled him with great anxiety. He was in despair because the miserable means available to painting never went far enough. 'He is trying to do what is impossible, and his religion is despair,' I thought to myself but still advised him to try to paint it – and that was how he came to paint his remarkable *Scream*.[22]

The formula of the road leading to nothing could be used as a simile for the fear of death, the sense of anxiety, with Munch himself now, rather than his father, appearing on it, leaning on a railing to hold himself back from the dizzying power of nature as it transformed itself into a bloody image of death. But the road to death also had to carry the message of the subjective sense of anxiety, the distortion of all reality which Munch felt as he walked along the road with his two friends, but which even they failed to recognize. And the painting had to render the hopelessness and ugliness of this mood, of the scream which stabbed through the silence of the sunset. How could he depict the fear he felt for his own life?

4. The Scream of Nature

Later in his life, Munch told one of his patrons that at the time he heard the scream in nature he felt a great fear of open places, found it difficult to cross a street, and felt great dizziness at the slightest height. The experience is one closely akin to Søren Kierkegaard's description of subjective anxiety in his book *Begrebet Angest (The Concept of Anxiety)*: 'We can compare anxiety to dizziness. He whose eyes look down into a yawning abyss becomes dizzy. But the reason for this is as much his eyes as it is the abyss itself. For we can easily suppose him not having looked down. Therefore anxiety is the dizziness resulting from freedom.'[23] Munch felt a close affinity to the Danish theologian and philosopher. In 1929 he wrote to the Swedish art historian Ragnar Hoppe, then preparing the catalogue of a major Munch exhibition: 'I am glad to hear you describe [my work] as exemplary of "Nordic spiritual life". People are always trying to shove me down to Germany. But we do after all have Strindberg, Ibsen, Søren Kierkegaard and Hans Jæger up here, and Dostoevsky in Russia. Only during the last year did I become familiar with Kierkegaard, and there certainly are remarkable parallels between him and me. Now I understand why it has so often been said that a similarity exists between his world and mine. Previously, I did not understand this.' What is of interest in this statement is Munch's insistent assertion that his art is founded on the experiences of the Scandinavian soul, and his attempt to support this assertion by the guarded reference to Kierkegaard, a reference immediately followed by the denial of any influence. This assumed ignorance must, however, be tempered by letters Munch wrote to friends at this same time relating how, while he was reading through his own earlier diaries, he was also renewing his acquaintance with Søren Kierkegaard's writings.

Among the collected works of Kierkegaard to which Munch sub-
scribed in 1920, *Begrebet Angest* is one of the few books read, its
pages carefully cut so as to avoid the more theoretical theological
sections.

For both Kierkegaard and Munch, the specific phobia of heights
and spaces became symbolic of a greater anxiety, the fear of death.
Their unbalanced dizziness was also experienced by Julian the
Apostate in Henrik Ibsen's play of 1873, *The Emperor and the
Galilean*, who described a vision of himself isolated on a vast,
motionless ocean:

Suddenly the surface became more and more transparent, lighter and
thinner. Until finally it no longer existed and my ship hung above an
empty, gaping abyss. There was nothing green, no sun down there – only
the dead, slimy black bottom of the ocean in all its repulsive nakedness.

But up above me, in all that endlessly curving vault which I previously
thought was empty – *there* was life. There chaos took on form and silence
sounded.[24]

Ibsen's, Kierkegaard's and Munch's anxieties are all rooted in the
same cause, in the self. There is less a fear of an external event or
thing which would cause harm than there is anxiety resulting from
turning inward, from self-contemplation. It is because the sunset
aroused a mood of desperation through introspection that Munch's
friends were unable to recognize the bloody, deadly quality of
nature he experienced. Similarly, Kierkegaard's anxiety is 'the
dizziness of freedom . . . as freedom looks down into its own possi-
bilities, and then grasps desperately for finite limitations in an
attempt to endure'. And Julian's vision in Ibsen's play is caused
by a metaphysical conclusion affecting all his beliefs, the conclusion
that 'what is, is not, and what is not, is'.

Anxiety and dread resulting from introspection likewise fasci-
nated the Norwegian symbolist poet Sigbjørn Obstfelder. His poem
'*Jeg ser*' (I see)[25] was written during the summer of 1892, while he
was often in Munch's company; even more than Ibsen or Kierke-
gaard, he approximates Munch's experience:

I see the white heavens,
I see the clouds of grey-blue,
I see the blood-red sun.

– So, this is the world.
So this is that planet's home.

– A raindrop!

I see the tall houses,
I see a thousand windows,
I see the distant church tower.

– So, this is Earth.
So this is man's home.

– The grey-blue clouds thicken. The sun vanishes.

I see well-dressed men,
I see smiling women,
I see running horses.
– How dark the grey-blue clouds are getting.

I see, I see . . .
Now I've come to the wrong planet!
Here it is so strange . . .

Using the effect of a Chinese box, Obstfelder proceeds from the contemplation of the cosmos, to that of the earth, to that of man and what surrounds him, and finally concludes in the contemplation of his self. It is when he reaches the realms of the soul, of the subconscious, that everything suddenly becomes strange, that fear arises, the state of mind represented by the darkening clouds which engulf the sun. Anxiety and dread are projected from the interior to the exterior, from the subconscious to the conscious and onto the neutral occurrences of nature.

Munch's difficulty in finding a pictorial equivalent for his experience, the indecisiveness of which Skredsvig wrote, may have inspired him to write out the diary entry in Nice mentioned earlier; in this way, accompanied by the quick sketchbook drawing which recorded the setting, he had a precise record or memory with which he could work. Most likely, Obstfelder had heard of the incident,

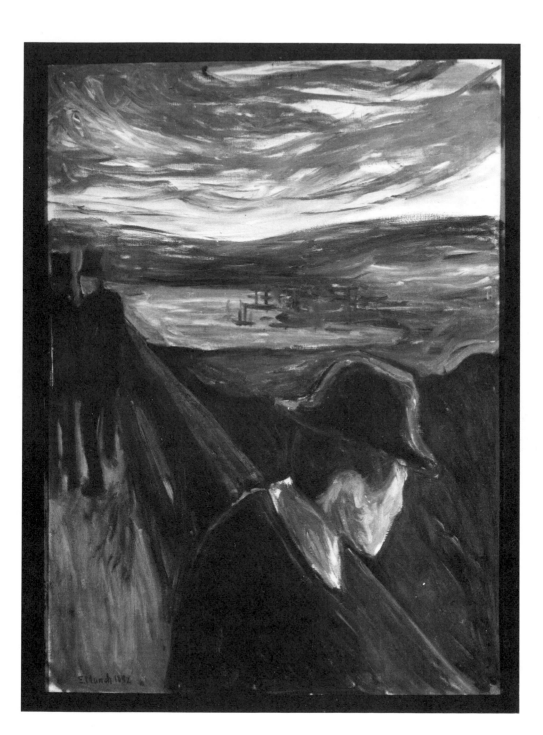

possibly had even read Munch's own brief text, and was thereby inspired to write 'Jeg ser'. Munch did not create a painting of his mood of anxiety until the summer of 1892, almost an entire year after the initial event. The painting was first exhibited in Kristiania in Munch's retrospective exhibition of 14 September to 4 October. Two catalogues exist for the exhibition; in both this painting bears the number eight, but whereas the first catalogue identified it solely as 'Mood at Sunset', the second described it more fully as 'Deranged Mood at Sunset' (*Syg Stemning ved Solnedgang*).

In this first painting, now known as *Despair* [32], Munch took the figure of the sketchbook drawing and brought it to the foreground, to the edge of the canvas and to the surface of the picture plane. The man is seen in profile, staring into the space of the painting, lacking visual contact with the viewer, but again serving the purpose of the Romantic's figures in landscapes, to act as the representative of the artist and aid the viewer's projection into the painting's mood. The railing on which he leans, like the railing of *Rue Lafayette*, creates a sharp, dizzying perspective, a cut into space which contrasts sharply to the flat, easily meandering curves of the fjord and mountains of the landscape. The sky is almost totally painted in bright, harsh reds, except for areas of bare white canvas and heavy stripes of bitter yellow; a very small area of pale blue appears towards the top of the painting. This blue, moving into a deeper hue, was used again to render the background landscape of mountains and fjord; in the foreground, it becomes mixed with dark tones of green. The two figures walking away echo the blackish blues of the landscape as does the dark clothing of the man leaning on the brown railing. The colors of the surrounding environment are again reflected in the touches of blue, green, brown and yellow appearing on his shirt collar. With the exception of the sky, the only bright area of the painting is the man's face; mixed in with the flesh tones and serving as highlights on it, the reds and yellows of the sunset reappear on the face and thus create a physical, as well as psychological, relationships between the two, indicating

32. *Despair*
(Deranged Mood at Sunset).
E. Munch, 1892

that nature reflects his despairing mood. The facture throughout the painting (except for the sharp lines of the railing and the heavy outline surrounding the foreground figure) is a modified impressionist brushstroke, large disconnected strokes of heavy paint running over each other so that no colors remain pure except the red and yellow of the sky.

The most dramatic aspect of the painting becomes the sky; a lesser reflective chord is struck by the featureless mass of the man's profile in the foreground. Attention is riveted on the blood-red, fire-like clouds that bite into the yellow sky – what contemporary critics compared to tomato catsup smeared over egg yolk. This streaked, striped sky has its source in meteorological phenomena visible in Oslo; the scene Munch depicts takes place on the eastern shores of the Oslofjord, on the road between Oslo and Nordstrand, on Ljabroveien. An extraordinary sunset effect can be observed in the late months of autumn when it often rains all day until the early evening when a cold front may push the moisture westward. As the sun then sets, it shines onto the clouds and mists (which hide all but the closest mountains) remaining after the rains and transforms them into stripes and tongues of intense reds and yellows in the blue sky. The phenomenon is an extremely impressive one, as unforgettable as it is indescribable. Numerous Norwegian artists before Munch had been fascinated by this sunset and had attempted to depict it, among them the Norwegian Romantic follower of Caspar David Friedrich, J. C. C. Dahl [33].

In 1888 a major retrospective exhibition was held in Kristiania of Johan Christian Clausen Dahl's paintings, an event of both nationalistic and artistic significance at a time when Norway was still seeking to define its independence from the remainder of the Scandinavian countries, to assert its equality in the union with Sweden. Gerhard Munthe (1849–1928), a major naturalist painter who turned to *stemningsmaleri* late in the 1880s, wrote that 'Professor Dahl has always interested me, and no matter how different from his is the art now growing in Norway, I still believe that he created

33. *Cloud Study at Sunset.*
J. C. C. Dahl, 1830s

something of the thoughts contained in it, and this is because his sense for what is national was sure and unerring, and because his soul was stronger and more dominant in him than in the [realist] painters of the forties and thereafter.' Dahl himself noted, 'I must confess that even while living in foreign countries, I am more of a Norseman than many living in Norway'. The landscape of Norway was the landscape of his spirit, the landscape to which he constantly returned for renewed inspiration, the landscape through which he contradicted Lessing's viewpoint that 'the landscape painter copies beauty and does not add anything ideal; he therefore works solely with his hands and his eyes, and genius has little or even nothing to do with his work.'[26] For Munch likewise, the landscape of Norway, notably the city of Kristiania and the seashore at Aasgaard-strand, became the visual embodiment of his spiritual life, the landscape of the *Frieze of Life*. The scream of nature takes place not in Nice or Paris or Berlin, but only and consciously in the landscape of the Oslofjord. Like Dahl, despite his travels and years living outside Scandinavia, Munch remained more of a Norseman than many of his countrymen remaining in the land of the Vikings. It was because the landscape of his youth had been transposed into a spiritual realm that Munch was so specific in locating the site of

the scream; Kristiania had become spiritualized into a universal setting of all human existence.

Dahl's landscapes were never as deeply subjective as Munch's were to be. As the Romantic painter and writer Carl Gustav Carus already recognized, Dahl was 'concerned with rendering all aspects of individual stones, and trees and plants and grasses, capable of reproducing all this with a uniquely personal mastery and in possession of a remarkable talent – but often the accidental attained too much power so that he could lose himself in too great an objectivity, just as Friedrich could at times drown in subjectivity'. What distinguishes the landscapes of Friedrich and Dahl, despite their relative differences of subjectivity and objectivity, from those of Munch is that they view man as an element in nature, as a portion of a pantheistic creation, whereas Munch sees nature solely as a reflection or mirror of a subjective mood. Contemplating nature, the Romantics discovered man's insignificance within it; through introspection, Munch discovered that the sole objective reality consisted of the worlds within himself, that external nature became an element of his psychological state.

The sunset of *Despair*, despite the faithfulness to meteorological and topographical phenomena, has its truthfulness solely in its reflection of the man's mood, in being an external manifestation and projection of his spiritual state, of his anxieties; again, this distinguishes the painting from Dahl's studies of moonlight or sunsets or clouds which exist outside of man, which set a mood into which man is absorbed and thereby becomes a participant. The Romantics' mood paintings seek to arouse and generate mood, to capture the emotional qualities of a natural phenomenon; the same is true of Munch's *Evening: Loneliness* [6] of 1888, where he found the mood in nature rather than bringing a pre-existing sense of loneliness to nature. The landscape and sunset of *Despair*, however, are visualizations of thoughts and dreams, and are created by the man contemplatively leaning on the railing in the foreground. The Polish writer Stanislaw Przybyszewski recognized this when

he used Munch's sunset mood of despair in one of his novellas, *Vigilien* (1895):

> Why did I have to love you?
> And a mood arises within me and then reflects my own deepest, innermost feelings onto the outside world in a rainbow of powerful light . . . And I see the sky dissolving into every color, into glowing fires, into clouds constantly shifting in great haste. Yellow-green at the edges, ash-grey above the violet-purple shore of the horizon, and from the west a jagged wound on the giant brow of the sky.[27]

The mood, the psychological state exists first and its reality is forced onto the external world so that it becomes subsumed into the emotion, becomes a visual correlate of the invisible mental reality.

Trained in Naturalism's belief that a painting must imitate reality, that there exist pictorial equivalents to the external world and that the painter can create these illusions so that they are recognizable to the public since they reflect its environmental reality, Munch had to find a pictorial solution for the representation of psychological reality, of the reality more real to him than the visual world which constantly changed under his subjective glance. In 1892 and 1893 he repeatedly argued that if he experienced clouds as blood during an agitated mood, then it would be false to paint the clouds in a normal manner, but rather he was explicitly bound to paint them as he experienced them, as coagulating blood. The aesthetic of Naturalism was faced with a new problem: whether to remain faithful to common visual experience or to become faithful to psychotic or deranged visions; Munch chose to be true to his visions. Przybyszewski verbalized the argument for Munch when he wrote in 1894:

> The last evolutionary stage of art – Naturalism – has made us alien to psychic and mental phenomena, has made our views of deep and infinite thoughts so shallow, that it is now absolutely impossible to project ourselves into a new artistic ideal which does not even make use of the tech-

nique of realism, which exists entirely in psychic areas, in the subtlest and finest emotions of the soul . . .

This is what makes Munch so great and so significant, that everything which is deep and dark, all that for which language has not yet found any words, and which expresses itself solely as a dark, foreboding instinct, that all this takes on color through him and enters our consciousness.[28]

The problem of painting his scream in nature, of symbolizing visually this psychological and aural phenomenon, was not, however, totally solved for Munch in his first painting of *Despair*. He copied the painting, including its black frame, in a charcoal drawing which sharpened the perspective rush of the railing into depth by decreasing the size of the two friends walking away and by increasing

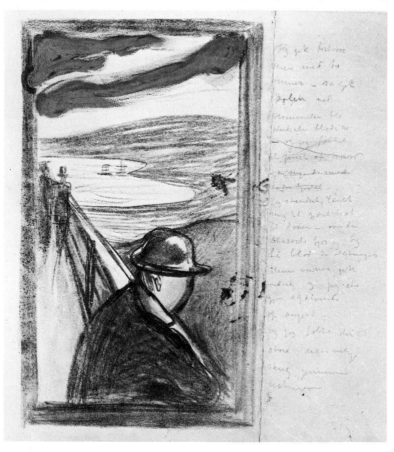

34. *Despair*.
E. Munch, 1892–3

35 *(right)*. *Despair*.
E. Munch, *c.* 1892

the bulk of the figure leaning on the railing [34]. The entire scene became more conceptualized, rendered solely in flat stylized areas with little attention paid to detail. These changes, as well as a change in the text accompanying the drawing so that it speaks not of 'clouds like blood and a sword' but rather of 'blood and tongues of fire'[29] – an image more in keeping with the simplified clouds painted onto the drawing than the still complex patterns of the painting – indicate that the drawing is a further study of the motif, an attempt to render the emotion more clearly and immediately.

Throughout 1892, Munch continued to rework the motif. It appears again in two small, pen-and-ink sketches [35] intended to serve as illustrations for the book of poems Emanuel Goldstein

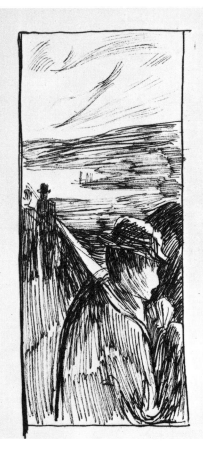
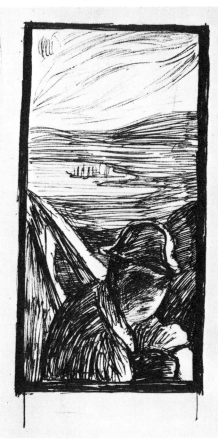

dedicated to Munch and for which Munch created the frontispiece. The first of these drawings, on the left-hand side of the sketch-book page, essentially repeats the painting and the charcoal-with-oil sketch, but the second drawing introduces a significant change: instead of looking into the painting, at the landscape scene, the figure in the foreground turns towards the viewer and stares out of the scene rather than at it, an action establishing contact with the viewer so that the figure acts as interlocutor between the scream of nature and Munch's audience.

The decision to have the figure turn away from the landscape, to face the viewer, resulted in a drastic change in the nature of the scene depicted. Prior to this, with the man melancholily brooding over the landscape, the scene was a neo-romantic one; *Despair* was a neo-romantic mood painting of a sunset, still using the quasi-impressionist facture, the loose brushstrokes of those paintings in rendering an essentially pleasing visual scene. Munch's technique did not match his visions, was still hampered by the traditions of Norwegian painting in which he participated throughout the 1880s. The final painting, *The Scream*, is in its nature a totally different type of creation, totally concerned with giving a psychological or spiritual experience visual expression.[30]

The Scream was first worked out in pastel on a piece of cardboard, a composition derived from *Despair* but at the same time essentially altered [36]. The two men, who had disappeared in the last pen sketch, appear at the left, one of them apparently looking out across the landscape as the figure of *Despair* had done, while the other one walks on. These two men mark a harsh vertical end to the intensified rush of the street and railing into depth, a movement which now begins at the lower right of the painting, not modified by the stable mass of the man's figure as in the previous painting. This dizzying perspective generation of space and movement in precise straight lines forms an antithetical movement to the major elements of the landscape and the sky, a movement into depth contrasting to the curving, absolutely flat expanse of the fjord and

36. Study for *The Scream*.
E. Munch, *c.* 1893

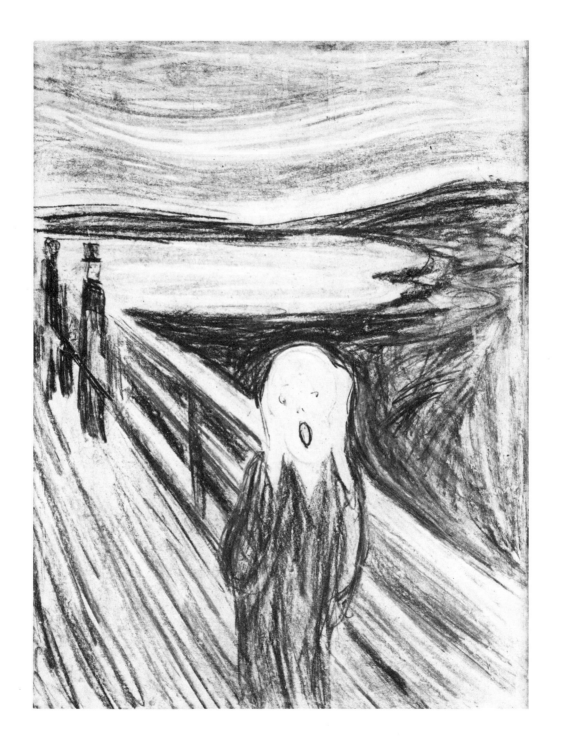

mountains. All the corrections or changes visible in the pastel study work to increase this tension between the two types of lines and between flatness and depth. The drama which previously had been limited to the colors of the sky now takes in the entire composition as Munch combines Van Gogh's perspective with the gentle curving meander of an art nouveau line and injects into both these elements that quality of unbalanced dizziness characterizing anxiety in the writings of Kierkegaard and Ibsen.

The figure in the foreground is now no longer a pensive one as in *Despair*, but has been moved from the side to the center and turned towards the viewer. With its arms raised to its head, perhaps covering its ears, the figure has its mouth wide open and screams directly at the viewer. It lacks the ramrod uprightness of the two friends in the background, and instead begins to bend slightly into an S-curve and assumes a shriveled quality. In the final composition, again on cardboard but now painted in a mixture of oils, pastel and casein, this figure differs even more from the pastel study, the qualities there suggested being intensified still further. Its completely flat body loses all effects of human anatomy and twists like a worm to conform to and extend the curves of the fjord landscape, to cut with their movement through the diagonal railing and carry the whipping curve onto the bottom of the composition. With this, the last remains of the neo-romantic mood of pensive sadness, of lyrically pensive *Weltschmerz*, of sleepy melancholy that set the *stemning* of *Despair* become totally destroyed and replaced by intense agitation, by loss of balance.

Color and space cease to have values in themselves, cease to be created for the sake of illusion which still lingered in *Despair*, and become subordinated to the expressive content of the painting. The color and facture which in *Despair* retained the imprint of impressionist *stemnings* painting, began to be changed in the pastel study into duller tones; browns mixed in with the blues and green of the landscape in rushed, mixed scratches of muddy color con-

trasting with the garish reds, golds and oranges of the sky and its one jolting stripe of pale but intense blue. The painting increases this dullness of all but the sky area; dull greens and blues mixed with brown color the landscape and also the screaming figure whose face remains the dull color of the bare cardboard with highlights and features added in greenish-white and dark-brown casein. On the right side of the painting a single red frame-like element adds a final vertical impetus, intensifying the flat curving upward rush of the fjord and mountain and city. The dizzying perspective, the space of anxiety, combines with a mold-colored landscape and a gangrenous sky to lend the painting its final unnerving impression on the viewer.

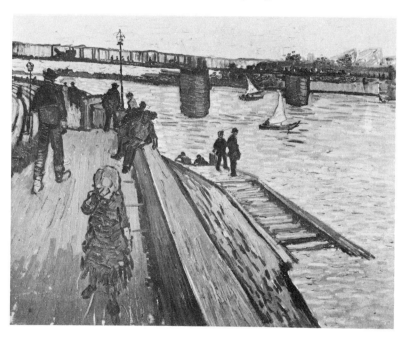

37. *Bridge at Trinquetaille.*
Van Gogh, 1888

The effect Munch achieved relates closely to the series of paintings Van Gogh created in 1888 of the *Bridge at Trinquetaille* [37] in which, as he wrote his brother, he wished to achieve something extremely distressful and heart-breaking in its subjective effect on the viewer.[31] But Van Gogh need not be the sole source; Émile

Bernard's paintings of the *Seine at Asnières* from 1887 [38], when
he was with Van Gogh, display the same type of deep perspective
jut into space contrasting a number of flat verticals or horizontals.
Moreover, this manneristic perspective had begun to be used by
other artists early in the 1890s. For instance, whether through in-
fluence or accidentally, Munch's *Scream* bears a far closer relation-
ship, both in composition and in content, to a painting by the
German illustrator Thomas Theodor Heine, whose opportunity to

38. *View of the Seine at Asnières.*
E. Bernard, 1887

be influenced by contemporary French art was close to non-
existent. Heine's painting *Before Sunrise* [39] depicts figures walking
into the background, workers on their way to the factory; in the
foreground, standing at a crossroad, is a woman staring out of the
painting, the temptation offered in place of the drudgery of work.
Behind her, in the direction of the factory, a road moves in exag-
gerated perspective and comes to a halt at the flattened mass of the
factory buildings and the mountains of the background. Color

39. *Before Sunrise.*
T. T. Heine, 1890

consists of a deep-red sky and a blue-green tinge over the remainder of the scene, so that color as well as composition and spatial effect closely approximate to those of *The Scream*. By the 1890s, the stylistic distortions of Van Gogh had become a common European property and their characteristics appeared in countries outside France, often without his work being a specific influence or exemplar.

Other aspects of Munch's *Scream* tie to the content of other contemporary works. The basic gesture of the screaming figure with

its hands raised to its head can be found again in Max Klinger's *In Flagranti* from the suite of etchings 'Dramas' (1883), where the deceiving woman has her hands pressed close to her head as part of her shocked reaction at having her lover shot by her husband. The gesture appears again in a painting by an artist greatly admired by Munch, Arnold Böcklin [40], where the shepherd runs anxiously

40. *Pan Frightening a Goatherd.*
A. Böcklin, 1860

away from the terrifying figure of the god Pan, and as he runs lifts his hands to his head in terror. Historically, the gesture has been a favorite one of painters to indicate great sorrow and/or terror; Mary Magdalene, for example, often raised her hands to her head,

at times to tear out her hair, while she grieved over the dead figure of Christ. But of course it need not be supposed that Munch intended any reference to the gesture's religious connotations. It is a common and perfectly natural gesture in a state of sudden fright.

But at the same time, the traditions of art were well known to Munch as someone trained in official academies both in Norway and in France, and it was largely this burden of knowledge of tradition which made *The Scream* so difficult for him to create. With the exception of *The Sick Child*, he worked on no other composition for a year or even more in the attempt to come to a satisfying solution: *Despair* was painted early in the summer of 1892; *The Scream* was not completed until some time late in 1893. To discover the reasons for this hesitancy, it is informative to turn once more to Lessing's *Laokoön*, which appeared in a new edition in 1893. The editor of what still remains the standard edition sought the help of Dr Julius Elias in interpreting and annotating the manuscript before its publication, so that when Munch appeared in Berlin late in 1892 and looked up Dr Elias, (also the translator of Ibsen's works), Lessing's study must have been much on the mind of the literary scholar. Since Munch was then also talking frequently about his scream in nature, he most likely discussed it with the man who became one of his earliest patrons in Germany,[32] and Dr Elias could have reminded him of the passage where Lessing discusses Laokoön's pain and why he sighs rather than screams in the statue by Agesander, Athenodorus and Polydorus of Rhodes.

The problem Lessing posed himself was why in literature Sophocles' Philoctetes could scream out loudly in pain but in sculpture Laokoön does not, despite the vehemence of his action and agony as he fights against the poisonous serpent coiled around him and his sons. Lessing concludes that this is because the aim of the sculptor was to attain the greatest degree of visual beauty possible under the circumstances given to him. 'He had to tone down the scream into a sob, not because screaming reveals a base or unheroic soul, but because it distorts the face in a repulsive

manner . . . Even without considering how forcibly and disgustingly the remaining portions of the face are twisted by it, the wide opening of the mouth is transformed into a dark spot in a painting and in a sculpture turns into a deep concavity, both of which have the most repulsive effect imaginable.'[33] As Dr Elias must have remarked to Munch, Lessing rejected the scream as a motif for the pictorial arts because its visual appearance was an ugly one and was unpleasing and disruptive even in Poussin's classicistic rendition of the *Massacre of the Innocents*, as well as in the Baroque version of the same motif by Guido Reni; to be rejected even more vehemently by Lessing's aesthetic would be works such as Bernini's *Anima damnata* in which the scream became the total content, much as in the painting Munch projected. Whether or not Munch knew of the art-historical precedents for a representation of a screaming figure, he had to decide to reject Lessing's goal of a beautiful painting before he could fulfill the demands of his anxiety-ridden sunset. To attain an expression true to the psychological power of his experience, he had to create an ugly painting.

5. The Scream of Despair

'Screaming,' wrote Lessing, 'is the natural expression of bodily pain.'[34] On one of the red stripes of his *Scream*, Munch penciled the words: '*Kan kun være malt av en gal mand!*' (Only someone insane could paint this!) The essential sources of Munch's and Lessing's screams are antithetical; Lessing's Greek heroes scream because physical pain is inflicted on them by an outside source, by spears or knives; Munch screams because the pain suffered is spiritual and projects its intensity outward into a physical expression. 'Insanity' was a necessary state of mind, and the painting became a translation and objectivization of subjective content.

Because its entire content is subjective and symbolic of something non-visual, *The Scream* must also be distinguished from those earlier representations of screaming figures which Lessing rejected. The anguish of the women whose children the Roman soldiers massacre results not from a set predisposition, but rather is the immediate physical reaction to the sight of slaughter. Bernini's damned soul screams as the fires of hell envelop it, the bodily pain gives rise to the terror-filled shriek. Without exception, a precisely specific cause, outside the screaming figure, gives rise to a unique and momentary reaction. Underneath his lithograph of *The Scream* [41], Munch wrote, 'I felt the great scream through nature'; it is no longer even an aural event, but rather something synaesthetically felt and recognized in nature and communicated as a vague un-located sensation moving through the entire body. The occasion, the immediate time and space of the sensation, may have been a sunset in Kristiania, but the necessary premise was Munch's 'insanity', his agoraphobia and alcoholism that produced the psychological phenomenon.

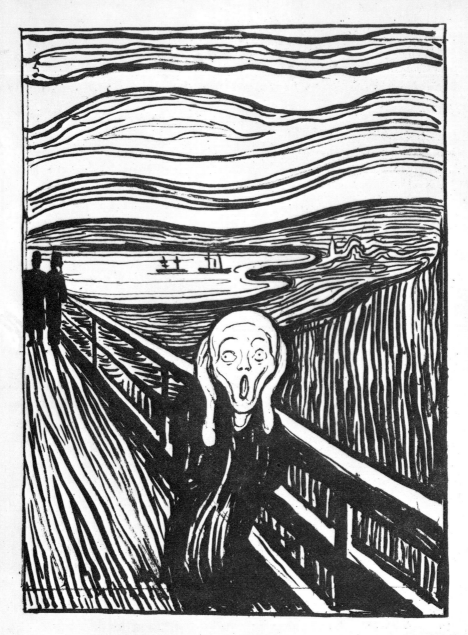

Geschrei

Edvard 1896

Ich fühlte das grosse Geschrei
durch die Natur

Psychologists since Freud have been fascinated with the degree to which an artist's work reflects his personality; notably Jung and his followers have sought to find in art the symbols of man's numerous neuroses. And Munch has proved a popular subject for their study because the subjectivity of his visions is so blatantly presented. Accordingly, the work of art becomes viewed as a translation and objectivization of subjective content into universally comprehensible and lasting symbols, i.e. a non-verbal image which communicates a meaning not verbally expressible. The pathological content of *The Scream* is then recognized as the fear of the loss of self-integrity, the fear of being incorporated into the environment.[35] Przybyszewski and other critics of the 1890s, once they overcame the initial repulsion felt towards Munch's technique and content, already discovered this meaning in the painting, so that it is less significant to retrace the reasoning of the psychologists than it is to analyze how Munch captured his near-psychotic sensation and why his contemporaries, as well as many other viewers, instinctively recognized what he was saying.

A common therapeutic practice is to have the patient depict his neuroses as though they were actually occurring and thereby to bring them under his control. It was a practice already used in 1908 by Munch's doctor, Professor Daniel Jacobsen, after Munch's nervous breakdown in Copenhagen, and the result was the series of lithographs *Alpha and Omega*; but Munch instinctively made use of the practice throughout his career, basing his paintings on his anxieties much as Strindberg founded his plays and novels on his subjective autobiography. But despite a recurring schizoid near-psychosis, actualized through alcoholic over-indulgence and most dramatically experienced as the scream in nature, Munch remained in tight control of his creative powers, and pitched these in battle against his anxieties. A highly introspective personality, he was at the same time unusually receptive to sensual stimuli, both visual and tactile, to the point where he could identify almost totally with the sources of these stimuli. At its greatest intensity, in erotic sensations,

41. *The Scream.* E. Munch, 1895

this receptivity appeared to him to result in a loss of identity in the other reality. The extreme tension existing between his intensified drive towards self-preservation and the threat located in an external separate existence bringing ego-destroying communicative experiences from the realm of the sensual led him to depict this subjective experience, to create a personal reality which could withstand the pressure of objective reality existing outside him. Of central significance for him was the integrity of the ego. For he constantly stood at the edge of Kierkegaard's precipice and felt the dizziness of that external reality he freely chose to let test its might against him, and all sensual impressions tied him to that external reality. Munch was forced to paint out of fear, to gain through his paintings a renewed actualization of his ego which could withstand the pressures of sensual stimuli. *The Scream*, more than any other work by him, was the symbol of this struggle.

By positing the unity of everything sensual, Munch could equate the landscape with woman, the visual power of nature with the erotic powers of woman; within the unity of sensual reality, the erotic is simply the realm of the most concentrated sensual intensity. *The Scream* could thus serve as the final tableau in the series studying the effects of love, and it is perhaps not accidental that the striations of landscape formations, notably in the lithograph version, take on the qualities of hair, often used by Munch as a symbol of the ego-overpowering incorporative powers of woman. The sexless, emasculated figure of *The Scream* loses itself in the environment as its skull-like face and twisting torso takes on the art nouveau curvature of the landscape rather than retaining human form. In its intense state of anxiety and despair, it becomes less real than the vitalized environment surrounding it and the loss of identity becomes death. The 'Despair' of the original title was Kierkegaard's 'sickness leading to death'.

The work of art for Munch was not complete until it communicated itself to an audience and the audience recognized the intentions of the artist. His paintings were created not solely to combat neu-

roses, and most likely not even primarily for this purpose, but to act as non-verbal symbols, and it was necessary that the audience comprehend them, that the artist keep his audience in mind as he sought his expression. The scream in nature was deliberately chosen as a symbol of despairing anxiety and death because Munch believed his Norwegian and German audiences would recognize its meaning, not only through the visual and formal devices which subsumed the figure into the landscape and perpetrated a dizzying perspective, but also through the situation itself. The various texts accompanying the versions of *The Scream* were to serve less as explanations than as reminders of something already known.

Until Emile Durkheim's *Study on Suicide* (1897) proved otherwise, the hour of sunset was popularly believed to be the most common time of suicides. This belief was used by the German author Georg Büchner in his short story, 'Lenz' (1839), as he described an evening immediately preceding an attempted suicide, and Lenz asks, 'Don't you hear it? Don't you hear that terrible voice screaming across the entire horizon and which we normally call silence?' Because he can no longer bear the sound of this scream and can find no other means of escape, he jumps from the window of his garret room. Since Munch, in some of his diary notes, likewise speaks of suicidal thoughts, the two situations are almost identical moods of despair.[36]

Heinrich Heine, who has been described as Munch's favorite poet, presented a scene in his poem 'Gotterdämmerung' which may point to a tradition still more closely associated with Munch than Büchner's Romantic story. Heine sees a dark monster grappling with the poet's angel as suddenly the entire universe is pierced by a shriek as the world ends. This apocalyptic view has its ultimate source in Nordic mythology, which had been resurrected by the Romantic movement and one of whose most popular compilations was written by Munch's uncle, the Norwegian historian Peter Andreas Munch. The parallel to Munch's *Scream* appears in *Njal's Saga* which recorded a scene witnessed immediately prior to a

battle: several women were seen weaving a tapestry, using human bones and entrails in their work, and on it appeared the images of all those warriors who were to die the next day. As they went about their weaving, they chanted 'The Spear Lay',[37] with the refrain:

> It is horrible now
> To look around,
> As a blood-red cloud
> Darkens the sky.
> The heavens are stained
> With the blood of men,
> As the Valkyries
> Sing their song.

As in Munch's descriptions of his experience of the scream in nature, clouds of blood combine with shrill, shrieking screams, the chants of the Valkyries weaving the tapestry of deadly fate. It is to this tradition with its context in Nordic warfare that Munch's initial description of a sunset 'like blood and a sword' also points.

For audiences in Scandinavia, to whom the Sagas were the fundamental nationalist literature, and for the German public of Wagnerian operas, Munch believed that his references in the text as well as the visual image of the scream would awake subconscious memories so that the meaning of despair and death would be communicated to them. The compositional devices he used which give evidence of the pathological significance of the painting, which point towards Munch's schizoid neuroses, were deliberately and consciously used for their expressive and informative values. Munch's paintings are autobiographic and psychologically revealing, again in a manner similar to August Strindberg's plays and novels, but they are deliberately so and are not unconscious revelations of neurosis in the manner of 'draw-a-person' tests administered by psychoanalysts. Munch narrates his major motif of man's acclimatization to his environment with a psychological honesty which necessitates a confessional attitude. He combines great spiritual experiences with objective insight and tightly controlled talent.

42. *Despair*. E. Munch, 1894

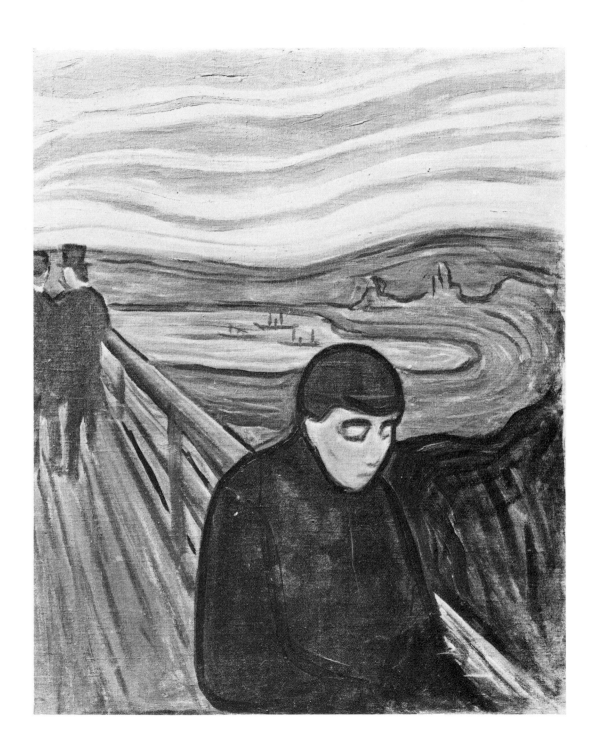

Both for his personality and his profession as a painter, *The Scream* was a highly significant event for Munch, one with which he remained occupied even after finishing the initial painting in 1893. The symbolic formulas he evolved in that work, the 'unhappy' descending lines of the perspective and the blood-filled sky, became embodied in other paintings in 1894 [42]. The melancholy tone of *Despair* which he completed in 1892 was resurrected, simplified and combined with the radical formulations of *The Scream*; the result is a rather additive composition, lacking both the intensity of *The Scream* and the neo-romantic melancholy of the earlier version of the motif as the figure of Jappe Nilssen replaces Munch in the foreground. More successful and equalling its paradigm in expressive power is *Angst* [43] where the screaming figure is replaced by the tightly-closed ranks of an advancing crowd. Dressed in black, the green-faced mass of anonymity marches towards the viewer and provides a funereal obstacle in his path; the eyes stare at him, the eyes of modern city-dwellers alienated from the majesty of nature and accustomed to being constantly confronted by ugliness. That Munch himself viewed this second composition as a more successful one than Jappe in despair is indicated by his translation of *Angst* into a lithograph and woodcut in 1896, among the first works to be created by him in these media.

As a means of increasing the availability of his images and thereby spreading his philosophy of love and death, Munch turned to graphics late in 1893. Jens Thiis recalled seeing the first drypoint engravings made by Munch in Berlin during the winter of 1893–4, and that after practising with the technique on a few portrait studies, Munch immediately turned to recreating motifs from his *Frieze of Life* and related works such as *The Sick Child*. In 1895, *The Madonna, The Vampire* and *The Scream* were among the first lithographs created; in 1896 *Angst* was also made into a lithograph and at the same time into Munch's first woodcut.[38]

Having completed these prints, Munch ceased to work on the motif of the scream and the blood-filled sunset except for occasion-

43. *Angst*. E. Munch, 1894

ally coloring one of the prints.[39] His schizoid neurosis attained increased intensity during the late 1890s in direct relationship to the development of a love affair with Tulla Larsen. As she became determined to marry Norway's most noted painter despite Munch's firm conviction that he should never marry, he traveled relentlessly throughout Europe, always closely followed by her. This pursuit caused him to drink still more, in turn bringing ever closer a spiritual crisis and breakdown; from the winter of 1897 until late 1900, Munch, who had habitually had at least one major exhibition a year since 1892, took part only in group exhibitions, and created almost no paintings and very few graphics. In the fall of 1899, he finally entered a sanatorium in Norway's Gudbrandsdal, determined to retrieve the peace he needed to work and regain control over his anxieties.

The marital pursuit did not end, however, and in 1902 his pursuer accidentally shot off a joint in the third finger of Munch's right hand – in Norway the hand on which the wedding ring would be worn. After this brutal termination of the affair, Munch desperately fought to retain his sanity, undertook numerous cures in German and Scandinavian bathing resorts, and deliberately attempted to turn to nature for new motifs, to paint landscapes instead of soulscapes and athletic male nudes instead of Vampire–Madonna women. If the format of *The Scream* reappears at times, as it does in the portrait of Friedrich Nietzsche [44], it is in terms of a reminiscence of earlier years. Munch could identify with Nietzsche, although the philosopher was only known to him indirectly through Przybyszewski's conversations and through collections of aphorisms. But with Nietzsche he purposely sought to say 'yes' to life, to deny death's shadowy adherence to life. Unlike the figure of *The Scream*, Nietzsche stands erect and powerful as he looks out across the precipice and landscape before him; calmly he surveys it and accepts it, unaffected by the dizzying aftermath of his thoughts, by the destruction of all values. And the diagonal of the railing moves upward, an affirming and joyful movement according to the interpreta-

44. *Friedrich Nietzsche.*
E. Munch, 1905–6

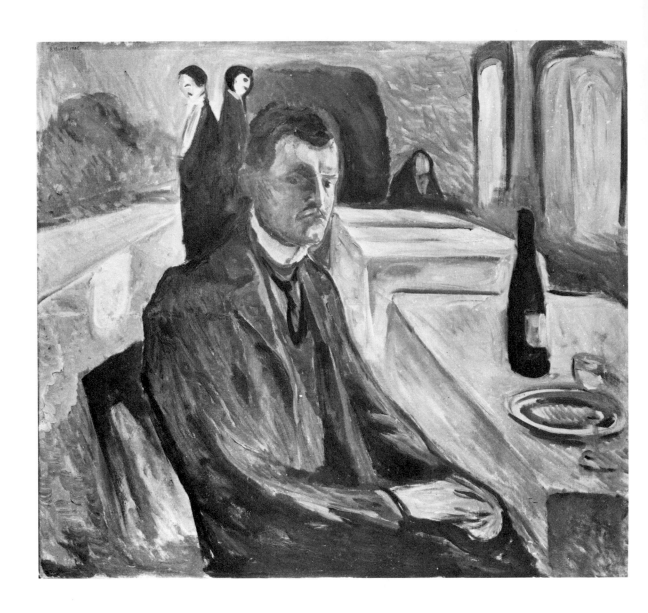

45. *Self-Portrait*. E. Munch, 1906

tions of linear motion made during the nineteenth century. The Nietzsche portrait serves essentially as an antithesis to *The Scream*, as an idealized self-portrait as Munch longed to be rather than the true spiritual self-portrait of *The Scream*. A series of idealized self-portraits created between 1902 and 1906 shows Munch self-consciously posing in hat and overcoat or in an artist's tunic, hiding the intense emotional turmoil he was undergoing at the time; casting himself in the role of Nietzsche, he created the last one of these self-deluding self-images. But at the same time as the Nietzsche portrait, Munch took up the *Scream* composition in another painting. In Weimar, in the restaurant of the Hotel Russischer Hof, Munch sits at a table on which there is an empty wine bottle. The wall behind him is painted a bloody red and the perspective lines of the table repeat those of *The Scream*, now echoed behind Munch by another table so that the two tables converge into a casket-like form within which Munch sits, as if trapped, motionless and powerless [45].

What Munch called his 'nerve-crisis' ended with the breakdown in Copenhagen in 1908; he was treated in the clinic of Dr Daniel Jacobsen and released from his care in May 1909. He immediately resumed his habit of restless traveling in Norway and Germany, but finally settled in the southern Norwegian seaport of Kragerø. Leading a recluse-like life, totally abstaining from alcohol, he began to work on paintings for the Aula of Oslo University. Concerning them, he wrote: 'The *Frieze of Life* is the joys and sorrows of individual men closely analyzed. The University Decorations are the great, eternal powers of life.'[40] In *The Sun* [46], he collects these eternal life-giving powers in their source, symbolizes the positive qualities of life, once more follows Nietzsche in saying 'yes' to life and embracing it. The same thoughts underlie the project for an additional Aula painting, *Towards the Light* [47], displaying mankind as it struggles towards its life-giving sources, towards the sun. The sun rises and gives life; in *The Scream*, it sank and brought death.

46. Study for *The Sun*. E. Munch, *c*. 1911-12

47 *(right)*. *Towards the Light*. E. Munch, *c*. 1911-12

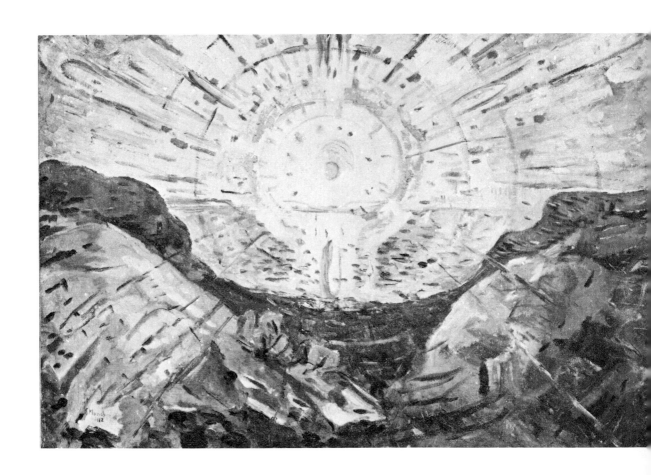

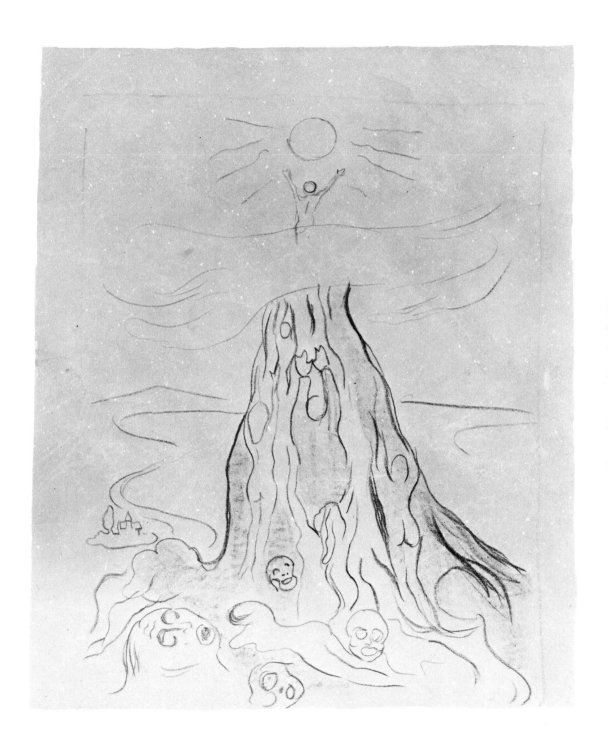

Appendix

The first of Munch's texts concerning his experience of a scream piercing nature was written in 1892. Thereafter he wrote several variations on this text and also approved of German and French translations. These texts are offered here in their original language accompanied by an English translation. In the original texts, those words crossed out by Munch are supplied in brackets.

I. DIARY ENTRY, DATED 22.1.92

[The text has been reworked with corrections added in a different ink than that used in the original writing.]

Jeg gik bortover veien med to venner – solen gik ned
– Jeg følte som et pust af vemod –*
– Himmelen blev pludselig blodi rød
Jeg stanset, lænede mig til gjærdet træt til døden [mine venner så på mig og gik videre –] så utover [på] over de flammende skyer som blod og svært [over fjorden og byen] over den blåsvarte fjord og by –
– Mine venner gik videre – jeg stod der skælvende af angst – og jeg følte som et stort uendeligt skrig gjennem naturen –

II. TEXT ON SKETCH OF *Despair*, *c.* 1892–3.

Jeg gik bortover veien med to venner – så gik solen ned. Himmelen blev pludseli blodi rø [– og jeg følte et pust af vemod – en sugende smerte under hjertet] Jeg standset, lænet mig til gjæret træt til døden – over den blåsorte fjor og by lå blod og ildstunger. Mine venner gik videre og jeg sto igjen skjælvende af angest – og jeg følte det gik et stort uenneligt skrig gjennem naturen.

*This line and the following one were reversed in order when Munch revised the text.

III. TEXTS ON REVERSE OF LITHOGRAPH OF *The Scream*, STAATS-
GALERIE, STUTTGART, *c.* 1895? FORMERLY COLLECTION OF
ARTHUR VON FRANQUET, ONE OF THE FIRST COLLECTORS OF
MUNCH GRAPHICS.

Jeg gik bortover Veien med to Venner. Solen gik ned – Himmelen blev
blodig röd – og jeg fölte et pust af Vemod – Jeg stod stille tret til Döden –
over den blåsorte Fjord og Stad la Blod og Ildstunger. Mine Venner gik
videre – jeg blev tilbage – skjelvende af Angest – Jeg fölte det store
Skrig i Naturen.

Auf Deutsch:
Ich ging mit zwei Freunden. Es sank die Sonne. Roth wie Blut wart der
Himmel, Wehmuth befiel mich. Ich stand still, krank und müde bis zum
Tod. Ueber dem dunkelen Fjord und der Stadt lag Blut und zungelndes
Feuer. Meine Freunde gingen weiter, ich aber blieb zurück, bebend und
bangend. Mir war als ging gellend ein Schrei durch die Natur.

In der ersten Fassung lauteten Munch's vorstehende, einem Gedichte
des Künstlers in Prosa entnommenen Verse, mit denen selbiger zu-
nächst das Bild malte:

Jeg gik bortover Veien med to Venner – så gik Solen ned – Himmelen
blev pludeselig blodi rød – og jeg følte som et Pust af Vemod. Jeg stand-
sede, lænede mig til Gjæret træt til Døden – over den blåsorte Fjord og
By la Skyerne som Blod og Ildstunger. Mine Venner gik videre og jeg
stod igjen skjælvende af Angest. Jeg følte det store uendelige Skrig
gjennem Naturen.

Auf Deutsch:
Ich ging (fürbass) mit zwei Freunden. Da sank (ging) die Sonne
(unter). Auf einmal wart (wurde) der Himmel roth wie Blut (blutig-roth)
und befiel mich Wehmuth (fühlte ich (er) wie einen Hauch von Weh-
muth) Ich stand still (und) lehnte mich gegen das Geländer, müde bis
zum Tode. Ueber den blauschwarzen Fjord und der Stadt lag der
Himmel wie Blut und Feuerzungen. Meine Freunde gingen weiter und
ich stand allein, bebend vor Angst. Mir war als ging ein mächtiges
Geschrei durch die Natur. (Ich fühlte ein grosses, unendliches Geschrei
ziehen durch die Natur.)

IV. TEXT ACCOMPANYING A REPRODUCTION OF *The Scream* LITHO-
GRAPH IN *La Revue Blanche*, 1 DECEMBER 1895, P. 528.

M'arrêtant, je m'appuyai à la balustrade, presque mort de fatigue. Au-
dessus du fjord bleu noir pendaient des nuages, rouges comme du sang
et comme des langues de feu. Mes amis s'éloignaient, et, seul, tremblant
d'angoisse, je pris conscience du grand cri infini de la nature. E.M.

V. TEXT PAINTED IN RED ON A BLACK SLAB BENEATH THE PASTEL
OF *c*. 1895:

Jeg gik bortover Veien med to Venner, Solen gik ned – Himmelen blev
blodig rød og jeg følte et Pust av Vemod. – Jeg stod stille træt til Døden.
– Over den blaasorte Fjord og Stad laa Blod og Ildstunger. Mine Venner
gik videre – Jeg blev tilbage – Skjelvende av Angest – Jeg følte det store
Skrig i Naturen.

VI. TEXT PUBLISHED BY MUNCH IN *Livsfrisens tilblivelse*, *c*. 1929,
P. 12.

Jeg gik en aften utover en vei – paa den ene side laa byen og fjorden
under mig.
Jeg var træt og syk – jeg stod og saa ut over fjorden – Solen gik ned –
skyene farvedes røde – som blod. –
Jeg følte som et skrik gjennem naturen – jeg syntes at høre et skrik. –
Jeg malte dette billede – malte skyene som virkelig blod. – Farvene
skrek. –
Det blev billedet Skrik i livsfrisen.

VII. TEXT WRITTEN IN AN UNPUBLISHED FOLIO OF DRAWINGS,
PRINTS, AND WRITINGS COMPILED BY MUNCH MOST LIKELY
DURING THE 1930S.

Jeg gik langs veien
Med to venner saa gik solen ned. Himlen blev pludselig blod og jeg
følte det store skrig i naturen.

VIII. TEXT WRITTEN IN A NOTEBOOK DISCOVERED IN 1971. IT WAS
APPARENTLY WRITTEN ABOUT 1905.

Jeg gik bortover veien med to venner –
og solen gik ned
Himmelen blev pludseli blod
– og jeg følte som et pust af vemod.
Jeg standset – lænet mig til gjaeret træt til døden.
Over den blåsvarte fjor og by
lå skyer af dryppende rygende blod.
Mine venner gik videre og jeg stod
igjen i angest med et åpent sår i mit bryst.
[Og jeg følte da gik] et stort skrik gik gjennem naturen.

English translations:

I. DIARY ENTRY, DATED 22.1.92

I was walking along the road with two friends. The sun set. I felt a tinge of melancholy. Suddenly the sky became a bloody red.

I stopped, leaned against the railing, dead tired [my friends looked at me and walked on] and I looked at the flaming clouds that hung like blood and a sword [over the fjord and city] over the blue-black fjord and city.

My friends walked on. I stood there, trembling with fright. And I felt a loud, unending scream piercing nature.

II. TEXT OF SKETCH OF *Despair*, *c*. 1892–3.

I was walking along the road with two of my friends. Then the sun set. Suddenly the sky became a bloody red. [and I felt a tinge of melancholy, a sucking pain beneath my heart] I stopped, leaned against the railing, dead tired. Over the blue-black fjord and city hung blood and tongues of fire. My friends walked on and I stood again trembling with fright. And I felt as if a loud, unending scream were piercing nature.

III. TEXTS ON REVERSE OF LITHOGRAPH OF *The Scream*, STAATS-GALERIE, STUTTGART, *c*. 1895?

I was walking along the road with two of my friends. The sun set. The sky became a bloody red. And I felt a touch of melancholy. I stood still, dead tired. Over the blue-black fjord and city hung blood and tongues of fire. My friends walked on. I stayed behind, trembling with fright. I felt the great scream in nature.

In German:

I was walking with two friends. The sun set. The sky became red as blood. Melancholy overcame me. I stood still, sick and dead tired. Above the darkening fjord and the city hung blood and flickering fire. My friends walked on, but I remained behind, trembling and frightened. I felt as if a droning scream was passing through nature.

The above verses by Munch, taken from one of the artist's poems in prose from which he created his painting, were as follows in the original version:

I was walking with two friends. The sun set. The sky suddenly became a bloody red. And I felt a touch of melancholy. I stopped, leaned against the railing, dead tired. Above the blue-black fjord and city hung clouds like blood and tongues of fire. My friends walked on and I stood again trembling with fright. I felt the loud, unending scream piercing through nature.

In German:

[In parentheses, the German translator provided alternate translations.]

I was walking (along) with two friends. Then the sun set (went down). All at once the sky was (became) red as blood (blood red) and melancholy overcame me (I (he) felt a touch of melancholy). I stood still (and) leaned against the railing, dead tired. Above the blue-black fjord and the city hung a sky like blood and tongues of fire. My friends went on, and I stood alone, trembling with fright. I felt as if a great scream was going through nature. (I felt a great, unending scream piercing through nature.)

IV. TEXT ACCOMPANYING A REPRODUCTION OF *The Scream* LITHO-GRAPH IN *La Revue Blanche*, 1 DECEMBER 1895, P. 528.

Stopping, I leaned against the railing, almost dead with fatigue. Out over the blue-black fjord hung clouds like blood and like tongues of fire. My friends walked away and, alone, trembling with terror, I became aware of the great, infinite scream of nature. E.M.

V. TEXT PAINTED IN RED ON A BLACK SLAB BENEATH THE PASTEL OF *c.* 1895.

I was walking along the road with two friends. The sun set. The sky turned a bloody red and I felt a touch of melancholy. I stood still, dead tired. Over the blue-black fjord and city hung tongues of fire. My friends walked on. I stayed behind, trembling with fright. I felt the great scream in nature.

VI. TEXT PUBLISHED BY MUNCH IN *Livsfrisens tilblivelse, c.* 1929 P. 12.

One evening I was walking along a road. On the one side lay the city and the fjord down below.

I was tired and sick. I stopped and looked out across the fjord. The sun set; the clouds turned red like blood.

I felt something like a scream through nature. I thought I heard a scream.

I painted that picture, painted the clouds as if they actually were blood. The colors screamed.

That became the painting *Scream* in the Frieze of Life.

VII. TEXT WRITTEN IN AN UNPUBLISHED FOLIO OF DRAWINGS, PRINTS, AND WRITINGS COMPILED BY MUNCH MOST LIKELY DURING THE 1930S.

I walked along the road. With two friends as the sun set. The sky suddenly turned into blood and I felt the great scream in nature.

VIII. TEXT WRITTEN IN A NOTEBOOK DISCOVERED IN 1971. IT WAS APPARENTLY WRITTEN ABOUT 1905.

I was walking along the road with two of my friends. Then the sun set. The sky suddenly turned into blood, and I felt something akin to a touch of melancholy. I stood still, leaned against the railing, dead tired. Above the blue-black fjord and city hung clouds of dripping, rippling blood. My friends went on and again I stood, frightened with an open wound in my breast. [And I felt passing through] A great scream pierced through nature.

Notes

1. Karl Scheffler, 'Berliner Sezession', *Die Zukunft*, xxxix (14 June 1902), pp. 419–30.

2. Unless otherwise indicated, all poems, other writings or statements by Munch here cited derive from his unpublished papers in the Munch Museum, Oslo. All translations into English are my own except where otherwise noted.

3. Edvard Munch, *Livsfrisens tilblivelse* (Oslo, c. 1929), pp. 4–7. Since the original manuscript containing this, Munch's best-known statement on his work is lost, and since 'The St Cloud Manifesto' was not cited by either Munch or his biographers prior to 1929, there is some doubt as to the original date and content of the Manifesto. The thoughts expressed, however, correspond to those in other writings by Munch originating about 1890. For details on this problem, see my Ph.D. dissertation, *Edvard Munch's 'Life Frieze': Its Beginnings and Origins* (Indiana University, 1969), pp. 52–61.

4. Letter to Ragnar Hoppe, dated February 1929. As published in R. Hoppe, 'Hos Edvard Munch på Ekely', *Nutida Konst*, I (1939), p. 16.

5. Ludwig Tieck, *Schriften* (Berlin, 1843), vol. 16, pp. 25 ff.

6. *Caspar David Friedrich in Briefen und Bekenntnissen*, Sigrid Hinz, ed. (Munich, 1968), pp. 92 and 128.

7. Friedrich Overbeck, letter dated 25 March 1810. As cited by Hermann Beenken, *Das neunzehnte Jahrhundert in der deutschen Kunst* (Munich, 1944), pp. 254–5.

8. Philipp Otto Runge, *Hinterlassene Schriften* (Hamburg, 1841), vol. I, p. 7.

9. As cited by Leif Østby, *Fra naturalisme til nyromantikk* (Oslo, 1934), p. 8.

10. Christian Krohg, 'Tredje Generasjon', *Kampen for tilværelsen*, 2nd ed. (Oslo, 1952), p. 174.

11. For a full account of Munch's first Berlin exhibition and the events surrounding it, see my article, 'Affæren Munch, Berlin 1892–93', *Kunst og Kultur*, lii (1969), pp. 175–91.

12. Hans Jæger, *Fra Kristiania-Bohemen*, 2nd ed. (Oslo, 1950), p. ix.

13. Hans Jæger, *Syg Kjaerlihet* (Paris, 1893) and *Fængsel og Fortvivelse* (Coucarneau, 1903).

14. For his aid in interpreting this print and identifying the people represented in it, I wish to thank Trygve Nergaard of the University in Oslo. He remains, however, innocent of the conclusions here presented.

15. Among Munch's papers is a letter of introduction addressed to Khnopff and written by Frits Thaulow, who had met the Belgian Symbolist at the Les XX exhibition of 1885. There is no indication whether or not Munch ever made use of the letter, but it does present rare evidence of his interest in another artist and a desire to meet him.

16. Much of the problem is one of terminology. Few artists actually identified themselves as Symbolists but symbolist tendencies are recognizable among a great number of artists between *c.* 1880 and 1910. For many of these artists, however, the fascination with paintings of symbolic content characterized only a relatively brief time in their careers. Since the investigation of this area of nineteenth- and twentieth-century art is a relatively new one, few if any definitive conclusions have been reached concerning it and discussions remain for the most part tentative ones.

17. Stanislaw Przybyszewski, ed., *Das Werk des Edvard Munch: Vier Beiträge* (Berlin, 1894), p. 47. Published by S. Fischer Verlag late in the spring of 1894, this was the first monograph dedicated to Munch's work. A collection of essays written by the Polish author Stanislaw Przybyszewski, with Munch one of the members of Berlin's bohemian *Schwarze Ferkel* (Black Piglet) circle of artists and writers, and by the art critics Franz Servaes, Willy Pastor and Julius Meier-Graefe, it is extremely valuable for its reflections of Munch's own thoughts at this time, and for documenting many of the paintings from 1893-4, probably the most productive years of Munch's entire career.

18. ibid., pp. 18-19. Przybyszewski's essay was originally published under the title 'Psychischer Naturalismus' in *Die Freie Bühne*, January 1894, pp. 150-56.

19. ibid., p. 21.

20. For this interpretation of the drawing, I am again indebted to Trygve Nergaard.

21. On Caillebotte's reception, see Marie Berhaut, *Caillebotte l'Impressioniste* (Lausanne, 1968), pp. 44 ff. Munch's desire for popular support and understanding is discussed by me at greater length in 'The Iconography of Edvard Munch's Sphinx', *Artforum*, IX: 2 (October 1970), pp. 72-80.

22. Christian Skredsvig, *Dager og nætter blandt kunstnere*, 3rd ed. (Oslo, 1943), p. 152.

23. Søren Kierkegaard, *Begrebet Angest, Samlede Værker*, vol. VI (Copenhagen, 1963), pp. 152–3.

24. Henrik Ibsen, *Kejser og Galilæer, Samlede Værker*, vol. I (Copenhagen and Kristiania, 1914), pp. 136–7.

25. Sigbjørn Obstfelder, 'Jeg ser', *Samlede skrifter*, Solveig Tunold comp., vol. I (Oslo, 1950), p. 48.

26. All citations from Andraes Aubert, *Maleren Johan Christian Dahl, et stykke av forige aarhundredes kunst- og kulturhistorie*, 2nd ed. (Kristiania, 1920), pp. 404, 3, and 352.

27. Stanislaw Przybyszewski, *Vigilien* (Berlin, 1895), pp. 15–17. Reproduced on the cover of the novella is a drawing by Munch of the *Madonna* motif. The copy owned by Munch bears the dedication:

<div style="text-align:center">

Meinem lieben Edvard

Stachu

Berlin, Weinachten [sic] 94.

</div>

Vigilien was originally published in *Neue deutsche Rundschau*, V (1894), pp. 865–89, so that Przybyszewski must have been writing it at the same time as Munch completed *The Scream*.

28. Stanislaw Przybyszewski, ed. *Das Werk des Edvard Munch: Vier Beiträge* (Berlin, 1894), pp. 4–5.

29. The two Norwegian versions of the text, accompanied by German translations, were also written for Munch on the back of a lithograph of *The Scream*, now in the collection of the Staatsgalerie, Stuttgart (see Appendix III, p. 106). In *c.* 1929 Munch published a collection of texts entitled 'Origins of the Frieze of Life' *(Livsfrisens tilblivelse)* which included one version of the experience (see Appendix VI, p. 105). An additional, modified version of the text was published with a reproduction of the lithograph in the *Revue Blanche*, no. 60, 1 December 1895 (see Appendix IV, p. 105).

30. On the reverse of the completed *Scream* painting of 1893 [48], the basic elements of the figure and landscape are rendered in thinned oil paint. The figure retains some of the stiffness characteristic of the pastel sketch and also does not continue the lines of the landscape, but rather is distinctly separated from the movement of the landscape by the lines of the railing. It seems most likely, therefore, that Munch painted the initial elements of his composition, recognized that they failed to meet his intentions adequately, and that he then turned over the

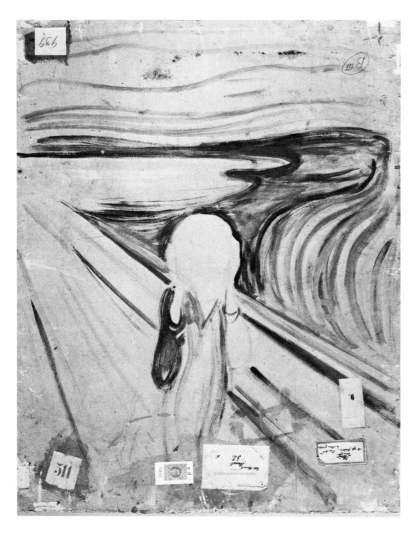

48. Sketch for *The Scream*.
E. Munch, *c.* 1893

piece of cardboard on which he worked to begin what became the
finished painting. When Munch exhibited this painting for the first
time, he gave it the title of his earlier painting *Fortvivelse : Despair*; the
catalogue of the 1893 Berlin exhibition at Unter den Linden 19 listed it
in the series 'Die Liebe' as number 4f, *Verzweiflung*. Munch's own
memory and the descriptions in the 1894 Munch monograph edited by
Przybyszewski, however, emphasized the actual scream as a personifica-
tion of a mood of despair; the visual symbol impressed more than the
mood in which it originated. Franz Servaes, for example, described the

world of the painting as a ' . . . madhouse, and in insane colors screaming together loudly in bloody reds and cursing yellows, the sky appears in whirling stripes like a shaken striped rug. The earth shivers, lamp posts move, people become insignificant shadows. It is I alone that exist in my endless terror. Shriveled into a repulsive worm-like form is the remnant of my body. My staring eyes and screaming mouth are all that I feel. Staring and screaming, screaming and staring, and feeling my stomach twisting – this is the only experience remaining in the madness of despaired love.' This emphasis on the visual scream rather than on the subjective mood in all descriptions of the painting probably caused Munch to change its title. At Stockholm in 1894, it bore the title *Skrig* for the first time and consistently retained it thereafter; in 1895, for another Berlin exhibition, Munch translated *Skrig* into *Geschrei*. Although he had studied English briefly late in the 1870s, Munch never translated his title into English; references to it therefore alternate between *The Shriek* (the most common translation), *The Cry*, and *The Scream*. However, neither *The Shriek* nor *The Cry* properly renders the meaning of either *Skrik* or *Geschrei*. A shriek is a sharp, piercing sound made in terror or pain and usually is quite quick and short, unlike the sound Munch felt approaching him through nature as he leaned against the street railing, a lengthy and extended sensation. A cry is likewise a loud utterance of strong emotion, but is most commonly associated with comprehensible words and need not be associated with a sense of terror or pain; the German word *Schrei* or the Norwegian *rop* are the proper equivalents for the meanings of 'cry'. The significance of *Skrik* or *Geschrei* is most closely approximated by *The Scream*; it is solely this translation which contains all the connotations of the prolonged, painful, harsh and loud, human emotional vocal outburst Munch projected into the landscape of the Oslofjord.

31. Van Gogh, *Complete Letters* (Greenwich, Conn., 1958), vol. II.

32. Cf. Munch's letter of 26 November 1892: 'I am often in the company of a rich Jew now, Dr Elias, a very good friend of Ibsen. I have already been to several dinner parties at his house.' *Edvard Munchs brev*, # 130, p. 123.

33. *Gotthold Ephraim Lessings sämtliche Schriften*, Karl Lachmann ed., with revisions by Franz Muncker, Vol. IX, *Laokoön, oder über die Grenzen der Malerey und Poesie* (Stuttgart, 1893), pp. 6–18. On the role of Dr Elias in the revision of this edition, cf. Franz Muncker's preface, dated 26 April 1893: 'Einzelne Punkte, die mir schliesslich doch noch

zweifelhaft geblieben waren, klärte mir Dr Julius Elias bereitwillig durch eine nochmalige genaue Vergleichung der Handschrift auf.' p.V.

34. Lessing, *Laokoön*, p. 8.

35. See, for example, the Jungian analysis provided by James Wingfield Digby, *Meaning and Symbol* (London, 1955), pp. 25-58, or Stanley Steinberg and Joseph Weiss, 'The Art of Edvard Munch and its Function in his Mental Life', *Psychoanalytic Quarterly* xxiii (1954), pp. 409-23. Less sectarian and more perceptive are the articles by Dr Hans Burckhardt, 'Angst und Eros bei Edvard Munch', *Deutsches Ärzteblatt: Ärztliche Mitteilungen*, LX (1965), pp. 2098-101, and 'Die Erotik in der Kunst Edvard Munchs', *Sandorama, das ärztliche Panorama*, no. 1 (1966), pp. 23-5. See also his study of schizoid pathology, 'Die Wahnstimmung als pathologisches Kommunications-Phänom', *Der Nervenarzt* (September 1964), pp. 405-12.

36. Georg Büchner's novella fragment is largely based on an event from the life of the German *Sturm und Drang* writer Jakob Michael Reinhold Lenz (1751-92). A fanatical follower of Goethe, Lenz entered a period of deep depression and showed marked signs of schizophrenia following the death of Goethe's sister, Cornelia, in 1777. To aid him in his recovery, Lenz was brought to the home of Dr Johann Friedrich Oberlin, a Lutheran priest in Steintal in Alsace. During the winter of 1778, Oberlin kept a precise account of Lenz's actions, including several attempted suicides, and this record formed the basis of Büchner's work in which Oberlin's text is altered but little. The description of the scream of silence, however, was supplied by Büchner and was not a part of Oberlin's original account. In 1779, Lenz returned to his native Lithuania, and he died in extreme poverty and unknown in one of the streets of Moscow in 1792.

It is unlikely that Munch would have read Büchner's *Lenz*, but he may very well have known of it through the circle of German writers with whom he associated during the 1890s. Largely forgotten after his death in 1837, Büchner was rediscovered during the 1880s and became a great influence on German authors of the 1890s and the early twentieth century, notably Gerhard Hauptmann and the Expressionists.

For a full consideration of Büchner's works and significance, cf. Herbert Lindenberger, *Georg Büchner* (Carbondale, Illinois, 1963).

37. *Njal's Saga*, Magnus Magnusson and Hermann Pålsson trans., Penguin Books (London and Baltimore, 1960), p. 351.

38. The woodcut of *Angst* and the lithograph of *The Scream* are unique among the *Frieze of Life* cycle in that Munch does not reverse the composition of the painting in the transfer to the print as was otherwise his practice. This indicates that the directional movement of the composition was a highly significant one and a meaningful element in these two works. Most likely this is because, when read from left to right, the perspective diagonal line of railing and street is a descending line. Contemporary studies on the psychological content of lines identify descending lines as generating an unhappy or sad mood; these findings were quickly repeated in the writings of numerous artists, notably Seurat and Pissarro. Had Munch reversed the composition, the directional movement of the lines would have become a 'happy' one, thus destroying the intensity of the sunset's drastic mood.

39. One additional version of *The Scream* exists from the 1890s, a pastel and oil signed and dated 1895 [49]. Essentially like the 1893 painting, it differs primarily in that one of the figures in the background leans onto the railing in the manner of the figure in Munch's first *Despair* sketch. Because of this detail, the date has been questioned by some authorities who argue that the pastel must be an additional study for the 1893 *Scream* and that Munch had not yet attained a definitive compositional solution for the motif. However, the pastel comes quite close to the 1895 lithograph in its conception, notably in the rendering of eyes and face of the foreground figure and in the simplification of the city's silhouette in the background, indicating that this must be a renewed study of the motif, probably for the lithograph version, or requested by the purchaser, Arthur von Franquet, and that Munch was attempting to combine the content of both *Despair* and *The Scream*. In this case, the 1895 date would be correct.

An additional painted version of *The Scream* [50] is to be found in the Munch Museum and is usually dated 1893, in the belief that it is contemporary with the painting in Oslo's National Gallery; there is, however, no evidence to support this contention. The rendering of the foreground figure, as well as of the fjord and sky areas, appears again to relate closely to the lithograph, so that we must assume that it rather than the 1893 painting served as a model and that therefore the date should be corrected to 1895 or later. The stance of the two walking figures in the background is, moreover, highly reminiscent of numerous representations of laborers made by Munch in 1908 and between 1914 and 1916, as is the use of very

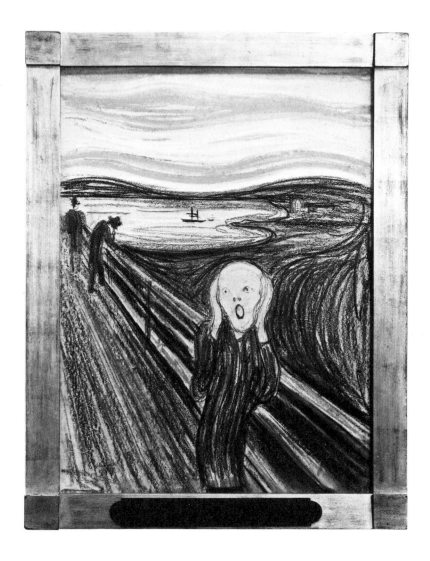

49. *The Scream*. E. Munch, 1895

50 *(right)*. *The Scream*. E. Munch, *c.* 1909 or 1915–18

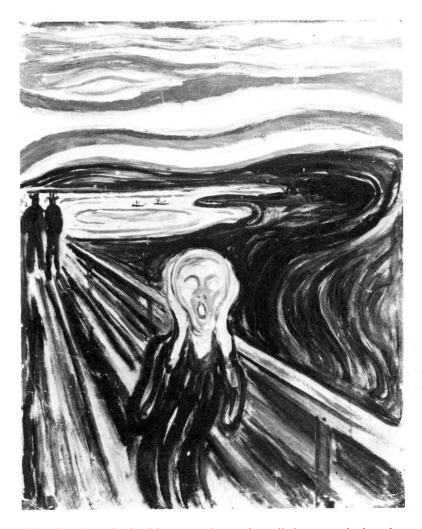

thin oil paint mixed with turpentine and applied extremely loosely, lacking both the exact control and intensity of formal interaction characteristic of the 1893 work. Munch was re-working many of his *Frieze of Life* paintings during 1915–18, and in 1918 exhibited some of these new versions. The painting may also have originated about 1909 when Munch sold the 1893 painting to the Norwegian collector, Olaf Schou. Until an exact study of Munch's work from after 1900 is made, however, a date of *c.* 1915–18 or *c.* 1909 must be tentative; what is certain is that the 1893 date heretofore applied is incorrect.

40. Edvard Munch, *Livs-Frisen* (Kristiania, *c.* 1918?), p. 3.

List of Illustrations

Color plate: *The Scream* by Edvard Munch, 1893. Oil, pastel and casein on cardboard, 91 x 73.5 cm. Oslo, National Gallery (Photo: Væring.)

1, 2, 3. *The Frieze of Life* by Edvard Munch, as exhibited at Galerie P. H. Beyer, Leipzig, 1903. The exhibition was identical with that of the Berlin Secession in 1902. (Photos: Archives of Munch Museum, Oslo.)

4. *Portrait of the Artist's Father* by Edvard Munch, *c.* 1881. Oil on canvas, 21.5 x 17.5 cm. Oslo, Oslo Community Art Collection, Munch Museum. (Photo: Museum.)

5. *The Sick Child* by Edvard Munch, 1885–6. Oil on canvas, 119.5 x 118.5 cm. Oslo, National Gallery. (Photo: Væring.)

6. *Evening: Loneliness* by Edvard Munch, 1888. Oil on canvas, 37 x 44 cm. Oslo, Sigval Bergessen d.y. Collection. (Photo: Museum.)

7. *Two Men watching a Sunset* by Caspar David Friedrich, 1819. Berlin, National Gallery. (Photo: Museum.)

8. *Self-Portrait under Woman's Mask* by Edvard Munch, 1892–3. Oil on board, 69 x 43.5 cm. Oslo, Oslo Community Art Collection. Munch Museum. (Photo: Museum.)

9. *Death in the Sickroom* by Edvard Munch, 1893. Oil and casein on canvas, 150 x 167.5 cm. Oslo, National Gallery. (Photo: Væring.)

10. *Portrait of Hans Jæger* by Edvard Munch, 1889. Oil on canvas, 109.5 x 84 cm. Oslo, National Gallery. (Photo: Væring.)

11. *From the Kristiania Boheme II* by Edvard Munch, 1895. Etching, dry point engraving and aquatint, 29.9 x 39.8 cm. Oslo, Oslo Community Art Collection, Munch Museum. (Photo: Museum.)

12. *Meeting at the Gate* by Max Klinger, 1887. From *Eine Liebe*. Frankfurt-am-Main, Städelsches Institut. (Photo: Museum.)

13. *Kiss* by Max Klinger, 1887. From *Eine Liebe*, as no 12.

14. *Embrace* by Max Klinger, 1887. From *Eine Liebe*, as no 12.

15. *Intermezzo* by Max Klinger, 1887. From *Eine Liebe*, as no 12.

16. *A Vision* by Max Klinger, 1887. From *Eine Liebe*, as no 12.

17. *Shame* by Max Klinger, 1887. From *Eine Liebe*, as no 12.

18. *Finale* by Max Klinger, 1887. From *Eine Liebe*, as no 12.

19. *The Voice (Summer Night's Dream)* by Edvard Munch, 1893. Oil on canvas, 88 x 110 cm. Boston, Museum of Fine Arts, Ernest Wadsworth Longfellow Fund. (Photo: Museum.)

20. *The Kiss* by Edvard Munch, 1892. Oil on cardboard (transferred to canvas), 100 x 80.5 cm. Oslo, Oslo Community Art Collection, Munch Museum. (Photo: Museum.)

21. *The Vampire (Love and Pain)* by Edvard Munch, *c.* 1893-4. Oil on canvas, 77 x 98 cm. Oslo, Oslo Community Art Collection, Munch Museum. (Photo: Museum.)

22. *The Madonna* by Edvard Munch, *c.* 1893. Oil on canvas, 91 x 70.5 cm. Oslo, National Gallery. (Photo: Væring.)

23. *The Madonna* by Edvard Munch, 1896-1902. Color lithograph, 61 x 44.1 cm. Oslo, Oslo Community Art Collection, Munch Museum. (Photo: Museum.)

24. *Jealousy* by Edvard Munch, 1893. Oil on canvas, 65 x 93 cm. Oslo, National Gallery, Christian Mustad Bequest. (Photo: Væring.)

25. *The Scream*, see color plate.

26. *Allegory of Death* by Edvard Munch, *c.* 1890. Pen and ink on paper, 11.3 x 17.2 cm. Oslo, Oslo Community Art Collection, Munch Museum. (Photo: Museum.)

27. *Allegory of Death* by Edvard Munch, *c.* 1893. Pen and ink on paper, 11.8 x 18 cm. Oslo, Oslo Community Art Collection, Munch Museum. (Photo: Museum.)

28. *Road with Cypress and Star* by Vincent van Gogh, 1890. Otterlo, Rijksmuseum Kröller-Müller. (Photo: copyright Holland.)

29. *Rue Lafayette* by Edvard Munch, 1891. Oil on canvas, 92 x 73 cm. Oslo, National Gallery. (Photo: Vaering.)

30. *Homme au balcon* by Gustave Caillebotte, 1880. Paris, private collection.

31. Study for *Despair* by Edvard Munch, *c.* 1891-2. Pencil on paper, 23 x 30.7 cm. Oslo, Oslo Community Art Collection, Munch Museum. (Photo: Museum.)

32. *Despair (Deranged Mood at Sunset)* by Edvard Munch, 1892. Oil on canvas, 92 x 67 cm. Stockholm, Thiel Gallery. (Photo: Museum.)

33. *Cloud Study at Sunset* by Johan Christian Clausen Dahl, *c.* 1830s. Oslo, National Gallery. (Photo: Væring.)

34. *Despair* by Edvard Munch, 1892-3. Charcoal and oil on paper, 33.7 x 20.7 cm. Oslo, Oslo Community Art Collection, Munch Museum. (Photo: Museum.)

35. *Despair* by Edvard Munch, *c.* 1892. Projected illustrations for Emanuel Goldstein's *Alruner*. Pen and ink on paper, 17 x 27 cm. Oslo, Oslo Community Art Collection, Munch Museum. (Photo: Museum.)

36. Study for *The Scream* by Edvard Munch, *c.* 1893. Pastel on cardboard, 74 x 56 cm. Oslo, Oslo Community Art Collection, Munch Museum. (Photo: Museum.)

37. *Bridge at Trinquetaille* by Vincent van Gogh, 1888. Washington, D.C., National Gallery of Art, lent by Mr and Mrs André Meyer.

38. *View of the Seine at Asnières* by Émile Bernard, 1887. New York, Museum of Modern Art. (Photo: Museum.)

39. *Before Sunrise* by Thomas Theodor Heine, 1890. Present whereabouts unknown.

40. *Pan Frightening a Goatherd* by Arnold Böcklin, 1860. Munich, Schack Gallerie. (Photo: Museum.)

41. *The Scream* by Edvard Munch, 1895. Lithograph, 32 x 25 cm. Oslo, Oslo Community Art Collection, Munch Museum. (Photo: Museum.)

42. *Despair* by Edvard Munch, 1894. (reworked *c.* 1915). Oil on canvas, 93 x 72 cm. Oslo, Oslo Community Art Collection, Munch Museum. (Photo: Museum.)

43. *Angst* by Edvard Munch, 1894. Oil on canvas, 93 x 72 cm. Oslo, Oslo Community Art Collection, Munch Museum. (Photo: Museum.)

44. *Portrait of Friedrich Nietzsche* by Edvard Munch, 1905-6. Oil on canvas, 200 x 130 cm. Oslo, Oslo Community Art Collection, Munch Museum. (Photo: Museum.)

45. *Self-Portrait* by Edvard Munch, 1906. Oil on canvas, 110 x 120 cm. Oslo, Oslo Community Art Collection, Munch Museum. (Photo: Museum.)

46. Study for *The Sun* by Edvard Munch, *c.* 1911-12. Oil on canvas, 122 x 176 cm. Oslo, Oslo Community Art Collection, Munch Museum. (Photo: Museum.)

47. *Towards the Light* by Edvard Munch, *c.* 1911-12. Project for Oslo University Aula. Pencil on paper. Oslo, Oslo Community Art Collection, Munch Museum. (Photo: Museum.)

48. Sketch on the back of *The Scream* by Edvard Munch, *c.* 1893. Oil on cardboard. Oslo, National Gallery. (Photo: Væring.)

49. *The Scream* by Edvard Munch, 1895. Pastel and oil on canvas. Oslo, private collection. Formerly Collection Arthur von Franquet, Braunschweig. (Photo: Munch Museum.)

50. *The Scream* by Edvard Munch, *c.* 1909 or 1915–18? Oil on cardboard, 83.5 x 66 cm. Oslo, Oslo Community Art Collection, Munch Museum. (Photo: Museum.)

Index